20th century portraits

exhibition at 15 Carlton House Terrace, SW1

Robin Gibson

NATIONAL PORTRAIT GALLERY

Published for the exhibition held from 9 June to 17 September 1978
at the National Portrait Gallery Exhibition Rooms,
15 Carlton House Terrace, SW1

Exhibition designed by Ted Gould

© National Portrait Gallery, London 1978
ISBN 0 904017 22 2
Published by the National Portrait Gallery, London WC2H 0HE

Catalogue edited by Mary Pettman
Designed by Paul Sharp
Printed by Balding and Mansell

Cover Gustav Klimt, *Friederike Maria Beer 1916* (no. 62)

Contents

Foreword

Art in the twentieth century has been dominated by a preoccupation with abstraction, culminating in the 'action painting' of the New York School. Critics have not had much to say about portraiture. Moreover, as the recording medium of photography became increasingly expressive, portrait painting (and sculpture) has been widely considered an anachronism. Nothing could be further from the truth. What if Rembrandt and Goya were alive today? And how could portraiture, in common with other forms of figurative art, fail to be an obsession amongst artists in a century of unparalleled turmoil, a world still reeling from the thunderbolt of 1914, when every advance in science and our knowledge of the universe only makes more poignantly clear how little we have yet discovered about the nature and behaviour of man? It is not a paradox that never before in the whole history of art has there been a more restless search, among artists of the front rank, for different means of expressing what they feel about the subject which is ultimately of the greatest concern to us all, namely, ourselves. One has only to think of the wit and inventiveness of cubism, the violence of *Die Brücke*, the merciless realism of a different kind of expressionism, *Die Neue Sachlichkeit* (Dix, Grosz, Spencer), the tortured self-examining of Francis Bacon. The present exhibition is about this search, and about the variety, richness and deepening of response to the conventional portrait commission, a process we may expect to see continue.

This is the first time the Gallery has mounted an international portrait exhibition, setting British art in a broader context, and it was with considerable diffidence that we wrote to museums and private collectors asking to borrow what were often amongst the most important works in their collections. The number of acknowledged masterpieces, as well as pictures of great historical significance, which we have been able to include is a tribute both to their great generosity and to their interest in the concept we had outlined. It seems invidious to single out lenders for special thanks, but we owe a particular debt of gratitude to Mr and Mrs Mark Mizne, who not only agreed to lend the painting we originally requested, but offered us any works from their collection in which we might be interested. This was magnanimity indeed. It is as a result of their exceptional generosity, and the kind cooperation of Dr Felix Baumann, Director of the Zürich Kunsthaus, that we are able to show the magnificent Klimt of Friederike Maria Beer – a special privilege, as it is the first time that a Klimt portrait of this calibre has been exhibited in Britain. For the Russian loans we are indebted to Mr U. M. Zhiltsov of the Soviet Ministry of Culture, and to the directors of the museums in whose charge they are. Particular thanks are also due to Sir Roland Penrose for much help and advice with loans, and to Gilbert Lloyd and Christopher Dark of Marlborough Fine Art Ltd.

The preparation of the exhibition has been in the hands of my colleague, Robin Gibson, and I am very grateful to him, not only for the care with which he has selected the exhibits but for the clarity of thought which he has brought to their discussion in the text which follows. The setting has been designed with characteristic sensitivity by Ted Gould.

JOHN HAYES
Director, National Portrait Gallery
April 1978

Acknowledgements

My principal debt is to the Director of the Gallery, John Hayes, without whose support and encouragement this exhibition would not have taken place. Other colleagues on the Gallery staff to whom I owe a special debt of gratitude are Jacquie Meredith, who undertook the considerable task of organising the loans and transport; Mary Pettman who patiently coaxed the text of the catalogue from me, ironed out the worst of its deficiencies and saw it through the press; and Sarah Wimbush who assisted me with research on the catalogue entries. Colin Ford, Kate Poole and Terence Pepper very kindly looked out the comparative photographs of the sitters for the exhibition display. The difficult task of typing the catalogue entries from a near-illegible manuscript was ably carried out by Susan White.

Outside the Gallery, I am greatly indebted to Keith Roberts who in the initial stages of the project helped me formulate my ideas and was subsequently a mine of information on every possible subject. I am also grateful for a useful exchange of ideas in a conversation with Juliet Steyn and Coline Covington who are working on the same subject. Dr Heinz Roland, Judith Jeffreys, Monroe Fabian Jr and Marlborough Fine Art were all helpful in arranging loans and providing information. Finally, to Ted Gould I owe the realisation of the exhibition in a sympathetic and imaginative setting.

R. G.
April 1978

Some comments on modern portraiture

Everybody thinks she is not at all like her portrait but never mind, in the end she will manage to look just like it.

> Picasso on his portrait of Gertrude Stein, quoted in R. Penrose, *Picasso, His Life and Work*, London 1958, pp.121–2

It seems to me unlikely that any important portraits will ever be painted again.

> John Berger, 1966, 'The changing view of man in the portrait', in *The Moment of Cubism and Other Essays*, London 1969, p. 41

I think it is true that only those totally without physical vanity, educated in painting, or with exceptionally good manners, can disguise their feelings of shock or even revulsion when they are confronted for the first time with a reasonably truthful painted image of themselves . . .

> Graham Sutherland, 1977, in *Portraits by Graham Sutherland* (exhibition catalogue), National Portrait Gallery, London 1977, p. 28

Who today has been able to record anything that comes across to us as a fact without causing deep injury to the image?

> Francis Bacon on his portraits, in D. Sylvester, *Interviews with Francis Bacon*, London 1975, p. 41

The retouched photograph has massacred serious portraiture.

> W. R. Sickert, in *A Free House* (ed. O. Sitwell), London 1947, p. 251

The adventure, the great adventure, is to see something unknown appear each day in the same face. That is greater than any journey round the world.

> Alberto Giacometti, quoted in D. Hall, *The Masters: Alberto Giacometti*, London 1963, p. 3

That which excites me the most, much, much more than the other things in my work – is the portrait, the modern portrait . . . I *would like* to make portraits that, a century later, might appear to people of the time like apparitions. Accordingly I don't try to do that by way of photographic resemblance but by way of our impassioned expressions, using as means of expression and exaltation of character our science and modern taste for colour . . .

> Van Gogh, in a letter to W. J. Van Gogh, Auvers, 1890 (first half)

To 'portray' (used in the best sense) has become synonymous with 'betray'.

> Graham Sutherland, 1977 (loc. cit.)

Introduction

The idea of mounting an exhibition of twentieth-century portraits stemmed originally from a sense of dissatisfaction and frustration with the Gallery's own modern collection and from the resultant urge to show that modern portraiture was not the lost cause it might well appear to be. It is true that this dissatisfaction could be due to over-familiarity with the collection on my part, but a good number of the NPG's portraits are a clear instance of the timidity of much establishment patronage of the arts in this century and of the generally insular level of British painting up to about 1940. Comparison of a 'Bloomsbury' product with a fauve or expressionist contemporary is on the whole fairly damning. There is still also a feeling, widespread even among quite distinguished critics, that ever since the invention of the photograph the portrait has been dying, and for some has long been dead. At the opposite end of the scale there are those who look on the portrait as a status symbol, a costly alternative to a colour photograph with only a cash relationship to a work of art. Both attitudes are equally prevalent and equally discouraging.

Why is it, then, that what might to all intents and purposes by now have been a thoroughly dead genre, has not only survived but has produced many of the very greatest masterpieces of the century? Think, for instance, of Picasso's *Gertrude Stein*, his cubist portraits of 1910 and his classic line-drawings; many of the greatest works of the German expressionists – Kokoschka, Dix, Beckmann, Schiele, Kirchner; some of the best-known works by contemporary British artists – Hockney, Sutherland, Kitaj, Bacon and Freud. Indeed, eighty per cent or more of Modigliani's *oeuvre* consists of portraits. All that this proves, of course, is not that the portrait has never been in decline but that critics and art historians have in the past probably overestimated the value and staying power of abstract art, with which figurative painting was for a number of years unfavourably compared.

In Britain there has also been a reluctance to appreciate the achievements of most of the major German artists of this century, in whose work the portrait has often found its greatest expression. Not since the days of Holbein and Dürer has there been anything to compare with the combined talents of Dix, Beckmann and Kokoschka. The concentration on the figure and personality is the culmination both of a long humanist tradition and of a certain lack of sympathy with the purely theoretical abstractions of some modern thought and art. The frequently violent nature of its expression probably accounts for its relative unpopularity here, and is certainly what disturbed Hitler and the Nazis. It is now possible to see, however, that most expressionist painting is only a logical outcome of Van Gogh's and Munch's passionate use of colour, and is firmly in the German tradition which produced Grünewald and many Gothic masterpieces. The 'will to abstraction' which has for many years undoubtedly been the major force in modern painting can no longer safely be assumed to be the ultimate goal of modern art.

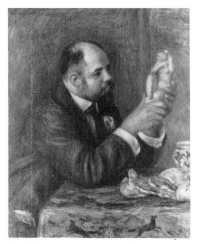

Fig. 1 Renoir, *Ambroise Vollard*, 1908 (no. 30)

The history of the modern portrait (greatly simplified, of course) is the history of modern art without the abstract movements. The considerable changes which the portrait underwent at the turn of the century are admirably demonstrated in the remarkable series of portraits of the great Parisian dealer, Ambroise Vollard. Although comparatively late in date, it is the Renoir portrait of 1908 which is the most retrospective, stylistically (fig. 1). Despite the obvious legacy of the artist's impressionist days in the treatment of light and texture, the image of the connoisseur in his cabinet may be traced back to the Renaissance; and Renoir indeed almost self-consciously emulates the old masters. If Bonnard was also untouched by the more avant-garde manifestations of these years, his portrait of 1904 is both impressionist in technique and naturalist in approach (fig. 2). The dealer, with no outward signs of his profession or position in life, is seen at home and pays no attention to either artist or spectator. The really revolutionary portrait, however, pre-dates both the Bonnard and Renoir and was painted by Cézanne in 1899 (fig. 3). In this strangely reticent work, it is possible to sense the sitter's documented boredom and impatience with the proceedings as Cézanne works out his complicated series of spatial relationships. It is as if the painter is almost unaware of his subject and sees him only in terms of pictorial problems. The same can be said with equal justification of Picasso's cubist portrait of Vollard, 1910 (fig. 4). The loyal dealer is the subject of an experiment along lines suggested by Cézanne; but Picasso takes the process almost as far as is possible without moving into abstraction. Only in the so-called two-faced heads of the 1930s (nos. 11, 29) does Picasso again approach the human face in a similar spirit.

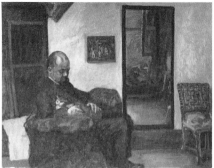

Fig. 2 Bonnard, *Ambroise Vollard*, 1904 (no. 17)

The idea of the sitter being secondary to the artist's style is not in itself new; in English terms, for example, a 'Lely' lady is always a 'Lely' lady, well before she is the Countess of Nottingham or whoever. What is perhaps new is the conscious imposition of style on the sitter, as, for example, Picasso painting out the face in his 1906 portrait of Gertrude Stein and substituting the lines of an archaic Iberian mask. A common misunderstanding of this action, voiced by Miss Stein's friends at the time and still current, was that the portrait did not and could not look like her. From comparison with photographs it is perfectly clear that the portrait looks very like her indeed. After eighty sittings it was in the impassive lines of the Iberian mask that Picasso suddenly found his personal solution to the problem of transcribing her features into a two-dimensional representation in tune with his current artistic preoccupations.

If, as stated, the concept of style superimposed on a portrait is nothing new, the fact that nineteenth-century portraits from Lawrence to Sargent tend to look very photographic to the modern eye is as much a comment on conventional portrait photography as on anything else. It is this sort of likeness which people have found so difficult to dissociate from the notion of a portrait. Freed by the photo-

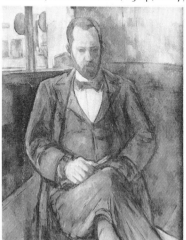

Fig. 3 Cézanne, *Ambroise Vollard*, 1899, Musée du Petit Palais, Paris (not in exhibition)

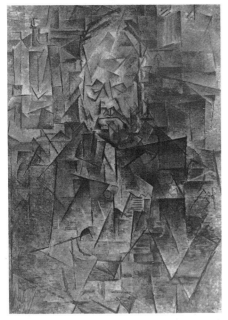

Fig. 4 Picasso, *Ambroise Vollard*, 1909–10
(no. 28)

graph from any responsibility for simply recording in a literal manner, most modern art has tended to be analytical in one way or another. It is however a fact of life that people do not like being analysed and exposed in public. This is what most modern portraits do; and this, combined with the lack of a conventional likeness, is what also accounts for the complete lack of comprehension with which the portraits are greeted. At the same time the photograph effectively freed the artist from demands for commissioned likenesses. Wary of the reaction he might receive from an unsympathetic sitter, he is now likely to be very choosy indeed about agreeing to paint someone. Nine times out of ten, it is the artist who will approach the sitter, for it is no longer a question of producing merely an appropriate likeness but a work of art.

The portrait has in a sense, therefore, now become more élite than ever. A hundred or so years ago, a little money could buy one a reasonable likeness to hang on the wall. A lot of money could probably secure a portrait from a good painter like Lawrence and a niche in history as one of his sitters. Today, no amount of money could possibly give a potential sitter this assurance. Statistics would probably show that in order to be absolutely sure of a portrait generally accepted as a great work of art, it would at least be necessary to be a member of the artist's family, or his dealer/patron. The wheel has thus turned full circle. We appear to have arrived at a situation similar to that in the *quattrocento*, when portraits were the exception rather than the rule, and only those closest to the artist were fortunate enough to be so immortalised. That the portrait has returned to its status as a major art form is however a cause for rejoicing.

This exhibition is dedicated to the proposition that the portrait has been a vital force in modern art and will in all probability continue to be so. Curiosity about one's fellow human beings is, after all, as basic as food and sex; the special relationship possible between the creative artist and the object of his interest does not disappear because there is a machine available to take the work off his hands. If the portraits in the Royal Academy summer show or the company board-room are a disheartening experience, it is not because portraiture is dead, any more than any other branch of the visual arts is dead; it is because the portraits are probably not very good. And there is no particular reason why at any given time they should be better than any other art form.

In choosing what the compiler of the exhibition considers to be among the best modern portraits, the final selection was necessarily influenced on the one hand by prior knowledge of the impossibility of borrowing those works acknowledged to be among the few great masterpieces of the century, and on the other by sheer shortage of space. The exhibition is therefore neither definitive nor comprehensive, much as I would like it to be. Instead, there is a fair scattering of works by some of the most famous artists of the century who have ever produced more than

Fig. 5 Picasso, *Ambroise Vollard*, pencil, 1915, Metropolitan Museum of Art, New York (not in exhibition). Picasso executed three more portraits of Vollard in aquatint in 1937.

one identified likeness, and a representative selection of the work of the very best painters who have regularly produced portraits. In addition, there are a number of portraits by lesser known artists whose work in this field probably deserves to be known better.

I have taken the year 1900 as my starting point and have tried to give a comprehensive coverage of most of those styles and trends which seemed to me to have lasting validity in the field of portraiture. Except for the purposes of comparison, photography has been ignored in this exhibition. Failure to capture a likeness is the criticism most commonly levelled at modern portraits, and for this reason it seemed unfair to include portrait photographs for their own sake. The exhibition is therefore consciously 'fine art'-orientated. I would be the last to deny that a newspaper photograph or child's drawing may be a far more valid image in every sense than the most competent portrait painting. However, that is not the point of the exhibition. The National Portrait Gallery, together with the Welsh Arts Council, attempted to explore the many different ways of creating a valid contemporary portrait in the *SNAP* exhibition in 1971.

With only some seventy items in an exhibition devoted to over seventy years of achievement, there are bound to be a number of omissions. There is, for instance, little more than a token coverage of sculpture, and the gaps as far as artists go are too obvious to draw attention to. Some of these, like the lack of a Redon or an Andrew Wyeth, are due to the fragility of the originals; others were regretfully excluded for lack of space or out of sheer ignorance. My criterion of a portrait was that some sort of a likeness of a particular person had been attempted within the limits of the artist's style. I have therefore not included purely experimental portraits of an abstract or symbolic nature, since whatever their pictorial significance, such images seem to me to demand a great deal of prior knowledge of the subject. I have also excluded all figure painting where the model, even if identifiable, has been consciously posed as something else, eg a nude or a mythological character. From this point of view, I have tried to stick to identifiable likenesses, although I am fully aware that in a number of those included, the artist did not intend the identity of the sitter to have any significance. Where this is known to be the case or where the portrait has a descriptive title, I have indicated as much in the text.

Due to the fragility of many of the originals, we were unable to borrow a named Jawlensky portrait, but I gratefully accepted the loan of one of his transitional heads because of their importance in twentieth-century iconography (no. 23). In the case of the two van Dongens (nos. 19, 20), I was seduced by the opportunity of including these amazing and virtually unknown examples of his shamelessly exuberant work. At the time of writing all three pictures are still unidentified, although clearly painted from particular models. I decided to show

the continuity of the *belle époque* tradition of portraiture not by the obvious choice of Sargent, who went on painting into the 1920s, but by a young painter of the period, Glyn Philpot, whose artistic identity was far less clear-cut and whose tremendous prestige at the time is often forgotten. Another out-of-the-way choice for which I make no apologies is the remarkable portrait of his daughter by Albin Egger-Lienz, and I am grateful to Herr Peter Baum, Director of the Neue Stadt-Galerie, Linz, for drawing this to my attention and offering to lend it.

Catalogue notes

Catalogue entries are arranged alphabetically by artist within each section. No attempt has been made to provide a full bibliography for each item; the one work mentioned is in every case assumed to be the most recent and most comprehensive reference to the portrait in question.

Measurements are given in centimetres and (in brackets) inches, height before width. Drawings and prints are assumed to be on white paper.

I

I *The artist and his family*

Children (nos. 2, 11), parents (nos. 6, 14) and wives (nos. 1, 3, 5, 8, 10, 12) are traditionally the artist's ever present models. Not since Rembrandt, however, have they played such an important role in the subject matter of the artist's work as they have in this century. Picasso's various women companions – Marie-Thérèse Walter, Dora Maar, Jacqueline Roque and Françoise Gilot – could even be said to have influenced changes in his style. They and his children (no. 11) are frequent models for paintings and sculpture, especially in his later periods. Giacometti's wife Annette (no. 5), and his brother Diego, sat for hours on end while he explored the infinite possibilities of the human face. Vuillard often pictured his mother as she went about her daily life in the closed world of their uneventful existence (no. 14).

Exploration of the 'self' in one medium or another has always been and is likely to remain a preoccupation in most fields of human creativity. The one possibly new development this century has been a number of 'abstract' self-portraits (eg those by Miro), presumably based on the not unreasonable premise that the artist *is* what he creates; but precedents for the use of what are after all symbolic images may be found in most religious art. The ultimate in modern self-portraiture is probably *performance art*, where the spectator is confronted with the artist in person. What the protagonists of this recent phenomenon have in common with the most prolific traditional self-portraitists is a strong element of exhibitionism. Corinth, Schiele, Beckmann and Bacon present themselves time and again in a manner which veers between a rather theatrical narcissism and a frantic search for self-identification.

MAX BECKMANN 1884–1950

Born in Leipzig; studied in Weimar, 1900–3; in 1910 was briefly connected with the impressionist-orientated Berlin Secession; reacted against earlier expressionism with the Neue Sachlichkeit *movement, but soon developed his mature style in boldly painted figure subjects often on mythological themes; Professor at Frankfurt from 1925 until dismissed by the Nazis, 1933; exiled in Amsterdam until 1947 when he emigrated to the USA.*

1

Quappi 1942
Oil on canvas, 90.2 × 70.5 ($35\frac{1}{2}$ × $27\frac{3}{4}$)
Signed and dated lower right: *Beckmann/A42*

LITERATURE F. W. Fischer, *Max Beckmann*, London 1972, repr. p. 63.

Portraiture, especially the self-portrait, forms an important part of Beckmann's *oeuvre*. He probably produced more self-portraits in paintings, drawings and prints than any other artist, including Rembrandt. 'Quappi' (Mathilde von Kaulbach), whom Beckmann married in 1925, is a frequent subject of his paintings, and her vivacious features are often discernible in the mythological works. This unusual portrait, with its heavy drawing and strident yellows, was painted during the difficult years of exile in Amsterdam, and perhaps conveys something of the anxiety of the Beckmanns' existence in occupied Holland. The way in which the figure is so abruptly cut off by the frame, and yet scarcely confined by it, is surely also highly expressive of the claustrophobia of conditions which at times came close to house-arrest.

Städtische Galerie im Niedersächsischen Landesmuseum, Hanover

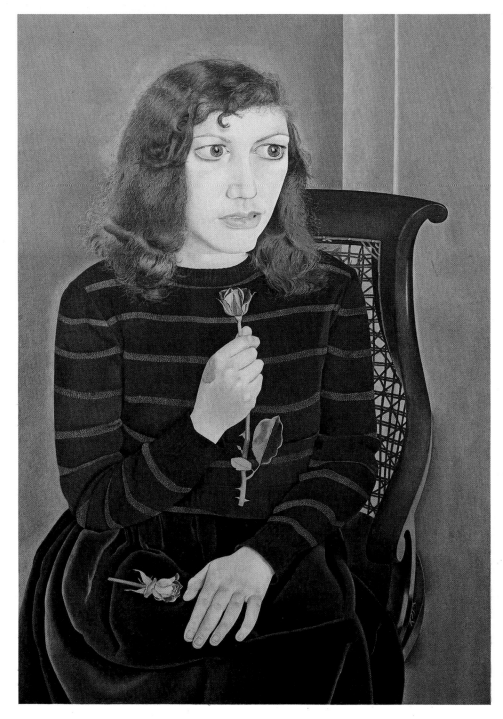

Colour plate I Lucian Freud, *Girl with roses*
1947/8 (no. 3)

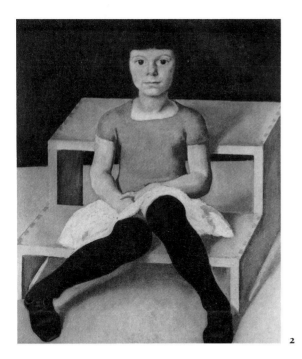

2

ALBIN EGGER-LIENZ 1868–1925

Austrian painter, born in Stribach, Lienz, the son of a well-known church painter; studied at the Munich Academy from 1885; influenced at first by Defregger, later by Hodler; taught at the School of Art in Weimar, 1911–21; during the war painted monumental pictures on heroic themes in a linear style, but later turned to peasant subjects with philosophical overtones.

2

Ila, the artist's younger daughter 1920
Oil on canvas, 83 × 73 (32¾ × 28¾)
Signed upper left: *EGGER LIENZ/1920*

LITERATURE H. Hammer, *Albin Egger-Lienz*, Innsbruck 1938 (not listed).

The Tyrolean painter Egger-Lienz is little known outside Austria, partly because his monumental war paintings and heroic peasants are out of tune with contemporary taste. Like his Swiss contemporary, Hodler, he can be seen in his later paintings to be working towards a thoroughly modern and personal idiom. This uncompromising portrait of his second daughter is a far cry from the rustic genre of Egger-Lienz's early years, and even from the prettier and more academic portraits of his other children, Lorli

(1907) and Fred (1908) (Hammer, op. cit. nos. 70, 71). Its sombre brownish tones and strong horizontals are characteristic of his mature work, but it is further distinguished by its freedom from symbolic imagery and the thoroughly modern approach to pictorial space.

Neue Galerie der Stadt Linz

LUCIAN FREUD born 1922

Born in Berlin, grandson of Sigmund Freud; came to England with his parents, 1932; studied at the Central School and Goldsmiths' College of Art; reacted against the neo-romanticism and good manners of current British painting with a meticulously observed and pitiless realism; his later work is more painterly in style.

3
Girl with roses 1947/8
(*Colour plate I, page 14*)
Oil on canvas, 105.5 × 75 (41½ × 29¼)

LITERATURE *Lucian Freud* (exhibition catalogue), Arts Council, London 1974, no. 44.

Although the greater part of Freud's work consists of portraits or figure paintings, the artist prefers his subjects to remain anonymous. This is partly because, as he is quoted as saying (op. cit. p. 13): 'My work is purely autobiographical . . . I work from the people that interest me, and that I care about and think about, in rooms that I live in and know . . .'; but it is also so that knowledge of the subject's identity does not colour the spectator's perception of the picture.

The *Girl with roses* is one of a memorable series of portraits known to be of the artist's first wife, Kathleen (Kitty), née Epstein. Its hypnotic and rather disturbing effect is probably as much the product of Freud's concentrated observation and meticulous technique as of any surrealist tendencies. 'My horror of the idyllic, and a growing awareness of the limited value of recording visually-observed facts, has led me to work from people I really know. Whom else can I hope to portray with any degree of profundity?'

The British Council

HENRI GAUDIER-BRZESKA 1891–1915

Born at St Jean de Braye in France; won scholarship to study in Bristol, 1906–8; returned to Paris, 1909, where he taught himself drawing and sculpture; met his lifelong companion, Sophie Brzeska, 1910, and took her name; settled in London, 1911, and managed to obtain a few commissions for sculpture; founder member of the London Group, 1914; contributed the vorticist sculpture manifesto to Blast; joined French army, September 1914; killed in action, June 1915.

4
Self-portrait 1912
Pencil, 56 × 38.7 (22 × 15¼)
Signed, inscribed and dated lower centre: *à Mme Hare Noël 1912/ Henri Gaudier-Brzeska*

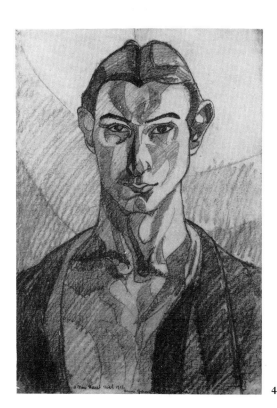

4

LITERATURE R. Cole, *Henri Gaudier-Brzeska* (exhibition catalogue), Scottish National Gallery of Modern Art, Edinburgh/Leeds/Cardiff 1972, no. 46, frontis.

This powerful drawing by the twenty-one-year-old sculptor is inscribed to his patron, Mrs Thomas Leman Hare, and was probably presented to her in gratitude for her assistance in finding a new studio at 454a Fulham Road (H. J. Ede, *Savage Messiah*, London 1931, p. 242). Stylistically it is probably closer to his plaster busts of 1913 (see no. 37) than to the brightly coloured cubist portraits of the same period (cf *Self-portrait* and *Sophie Brzeska*, Southampton Art Gallery). The monochrome medium and more curvilinear surfaces read in a very three-dimensional manner, rather like a schema for a piece of sculpture, and the shoulders are severed in the same way as a bust. Both drawing and sculpture show the individual form of cubism he had evolved, largely independent of French influences.

National Portrait Gallery, London

ALBERTO GIACOMETTI 1901–66

Swiss painter and sculptor; born in Stampa (Grisons), the son of a distinguished painter, Giovanni Giacometti, and nephew of another, Augusto; trained by his father in Geneva, and from 1922 to 1925 with Bourdelle in Paris; early work cubistic, then surrealist; from 1937 evolved the distinctive elongated and emaciated style for which he is best known.

5
Annette IV 1962
Bronze, 58.5 × 25 × 22 (23 × 10 × 8½)
Inscribed lower right side: *Alberto Giacometti/o/6*

LITERATURE *The Tate Gallery Report 1965–66*, London 1967, p. 31.

Giacometti's wife, Annette Arm, whom he met in Geneva during the war and married in 1949. With her brother-in-law, Diego, she was one of Giacometti's most frequent models, and was able

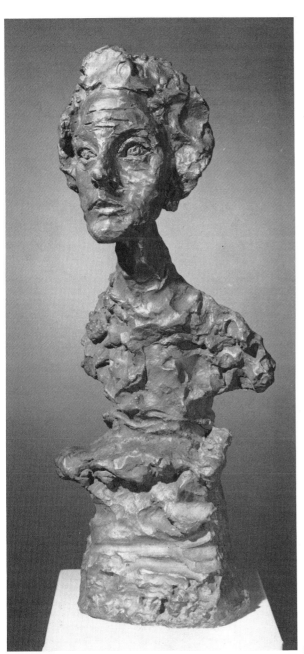

5

to bear the long sittings and absolute concentration which he demanded. 'The adventure, the great adventure is to see something unknown appear each day in the same face', he said; 'That is greater than any journey round the world'. Giacometti preferred to return to the same head time after time, and was able to do so with complete detachment. Jacques Dupin related that 'once, after Annette had posed the whole afternoon, Giacometti gazed at her that evening in the café. Annette, surprised: "Why are you looking at me that way?" Alberto: "Because I haven't seen you all day."' (R. Hohl, *Alberto Giacometti*, London 1972, p. 276.)

This bust, one of a series numbered I to VIII, produced in 1962, marks a new stage of 'realisation' in Giacometti's heads; it is more three-dimensional than his earlier heads, and is placed on a 'pedestal', like a traditional portrait bust.

The Trustees of the Tate Gallery

DAVID HOCKNEY born 1937

Born in Bradford; studied at Bradford School of Art, 1953–7, and the Royal College of Art, 1959–62; with his highly personal approach to the 'pop' idiom won several major awards; first one-man exhibition at the Kasmin Gallery, 1963; retrospective exhibitions at the Whitechapel Art Gallery, 1970, and the Musée des Arts Decoratifs, Paris, 1974; a biographical film, A Bigger Splash, 1974, contributed towards his already considerable international reputation and fame.

6
My Parents 1977
Oil on canvas, 183 × 183 (72 × 72)

EXHIBITION *David Hockney – New Paintings Drawings and Graphics*, André Emmerich Gallery, New York 1977.

This is the second of two large portraits of the artist's parents. The first, which was completed in 1975 and has a self-portrait of Hockney in the mirror, was in many ways more objective, as the non-representational triangle behind the figures suggests (see *David Hockney by David Hockney*, London 1976, plate 40). In the

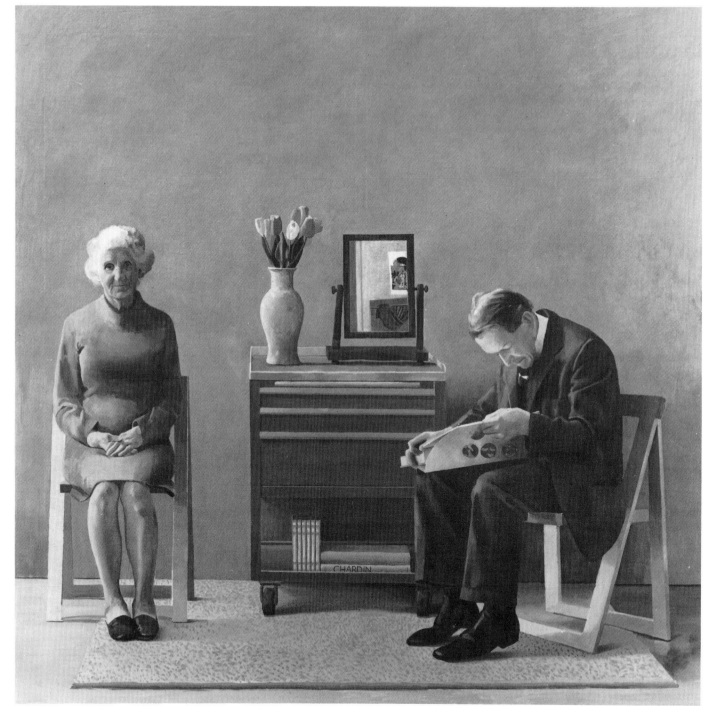

6

1977 portrait, the volumes of Proust (now increased in number) still signify 'remembrance of things past', but the *Chardin* book indicates a new preoccupation. The reproduction of the Piero della Francesca, reflected with the corner of Hockney's *Invented Man revealing Still Life* (1975) in the mirror, also emphasises the mood of stillness and the magical quality of the light. This is a moving and personal 'still life' with few parallels.

The artist

OSKAR KOKOSCHKA born 1886

Austrian painter and writer, born at Pöchlarn; first exhibited at Vienna Kunstschau, 1908, where his highly original expressionist paintings aroused antagonism; received his first commissions for portraits with the help of Adolf Loos, and contributed drawings to Herwath Walden's magazine Der Sturm; *Professor at Dresden Academy, 1918; altered his style in the 1920s under the influence of the impressionists; travelled extensively between the wars, and came to England in 1935; naturalised British subject, 1947; now lives in Switzerland.*

7
Self-portrait 1965
Lithograph, 98.7 × 65.4 ($37\frac{7}{8} \times 25\frac{3}{4}$)
Signed in pencil lower right: *O Kokoschka*; numbered lower left: *12/50*

LITERATURE H. M. Wingler, *Oskar Kokoschka, Das Druckgraphische Werk*, Salzburg 1975, no. 358, repr.

Kokoschka has produced a great number of self-portraits, both paintings and graphics, and has frequently used himself as a model for his allegorical works (cf *The Tempest*, 1914). Prints and drawings, especially for portraits and still lifes, have become the preferred medium of the artist's old age, and since this lithograph he has produced at least one self-portrait print almost every year. One of the most dignified and hieratic of all the series, this one was used as the poster for an exhibition at Leiden, commemorating Kokoschka's eightieth birthday.

National Portrait Gallery, London

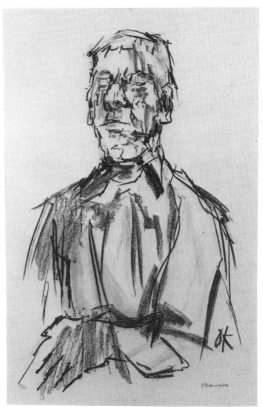

7

HENRI MATISSE 1869–1954

Born in Cateau; studied law until 1890; met Marquet and Rouault while studying at the École des Beaux-Arts under Moreau, 1892–7; later met Derain at the Académie Carrière; the group's brightly coloured pictures at the Salon d'Automne exhibition of 1905 gained them the nickname of the fauves; *patronage by the American Stein family and the Russians, Shchukin and Morosov, spread Matisse's fame and enabled him to develop his experimental approach to colour, 1905–10; influenced by near-Eastern art, 1910, and travelled widely in Europe and North Africa until 1914; spent much of his life on the Riviera painting the odalisques and still lifes for which he is known; the paper cut-outs of his last years marked an original new development in his art.*

8

Madame Matisse 1913
Oil on canvas, 145 × 97 (57 × 38)
Signed lower right: *Henri Matisse*

LITERATURE A. Kostenevich, *The Hermitage: Western European Paintings of the Nineteenth and Twentieth Centuries*, Leningrad 1976, no. 126, repr.

Matisse married Amélie Parayre from Toulouse in 1898. By the time this portrait was painted they had three children, and Matisse here depicts her as an elegant Parisian housewife. Amélie had posed for a number of Matisse's earlier works, including the 1909 *Conversation* (also in the Hermitage) where he was attempting to come to terms with the colour blue. This portrait is, in a sense, a continuation of the experiment with blues, but is combined with a search for new ways of portraying the human figure in terms of colour and form. This search found its most extreme expression in the portraits of Yvonne Landsberg in 1914 (Philadelphia) and Greta Prozar in 1916 (private collection, New York), after which Matisse's figure paintings became more conventional and typical of his mature work.

A critic who saw the painting at the Salon d'Automne in 1913 decided, perhaps understandably, that it must have been dashed off hastily. Matisse told him that it had required more than a hundred sittings. As with Picasso's cubist portraits (see no. 28), this is more an indication of the experimental nature of the work than of any difficulty in achieving a likeness. Matisse's quoted belief that 'the expression he wanted in art was not mirrored in the human face' is very evident here, but the portrait remains a beautiful and rather touching work, the blues and turquoise colours giving it a note of melancholy.

Hermitage Museum, Leningrad

AMEDEO MODIGLIANI 1884–1920

Born in Leghorn, Italy, son of a Jewish banker; studied at the Venice Academy, and settled in Paris, 1906; after meeting Picasso, Soutine, Max Jacob and others, was influenced by African sculpture and radically altered his style; his life the epitome of the bohemian artist; suffered from tuberculosis, living in extreme poverty and indulging in drink, drugs and wild love affairs; sold very little before his premature

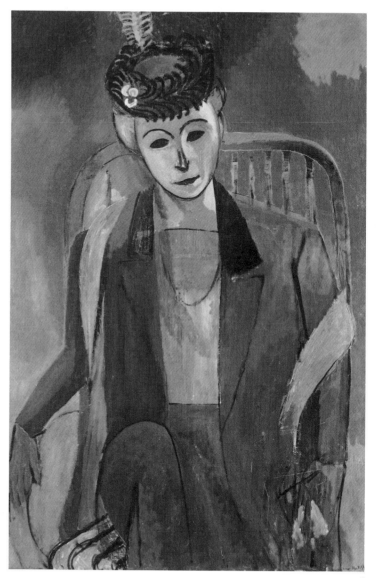

8

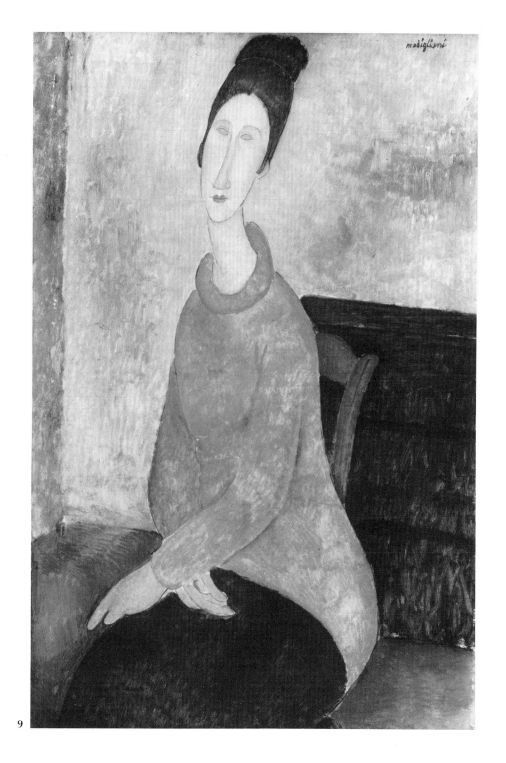

9

death; apart from the famous nudes and sculpture, most of his oeuvre consists of portraits, named or anonymous.

9
Jeanne Hébuterne with yellow sweater 1918/19
Oil on canvas, 100 × 64.7 (39⅜ × 25½)
Signed upper right: *modigliani*

LITERATURE A. Z. Rudenstine, *The Guggenheim Museum Collection: Paintings 1880–1945*, New York 1976, no. 189.

One of about twenty-six portraits which Modigliani painted of his devoted companion, Jeanne Hébuterne, between 1917 and his death. The daughter of a cashier in a Paris parfumerie, she was an art student at the Académie Colarossi when she met him. In July 1917 they rented a joint studio, and their child, Jeanne, was born in Nice, November 1918. Although believed to have been painted during their year in the south of France and to show her pregnant, it is not yet possible to establish an exact date for the portrait. Jeanne was already nine months pregnant again when she jumped to her death from her parents' fifth-floor flat, the morning following Modigliani's death on 24 January 1920. Despite the problems of over-familiarity with the image, the painting is a masterly yet touching example of Modigliani's feeling for individual character. Jeanne's grace and vulnerability are complimented by Modigliani's supple line and virtuoso handling of colours.

Solomon R. Guggenheim Museum, New York

ROLAND PENROSE born 1900

Artist and art historian; studied and painted while living in France, 1922–34; founder member of surrealist group in England; organised International Surrealist Exhibition in London, 1936; founded Institute of Contemporary Arts, 1947, of which he was chairman until 1969 and then president until 1976; lifelong friend and biographer of Picasso; has organised many important exhibitions; author of books on Miro, Picasso and Man Ray; knighted, 1966.

10

10
Winged Domino or **Portrait of Valentine** 1937
Oil on canvas, 60 × 45 (23½ × 17¾)
Signed lower right: *R. Penrose*

LITERATURE Dawn Ades, *Dada and Surrealism Reviewed* (exhibition catalogue), Arts Council, London 1978, no. 14.55, repr.

A portrait of the artist's first wife, the poet Valentine Andrée Boué. She was associated with the surrealist movement and contributed to several periodicals, including *VVV* and *Dyn*. This 'enchanted' image was originally reproduced in the *London Bulletin*, no. 17, 1939, as *The winged domino*, and, as with much surrealist painting, it is probably a mistake to try and interpret it. The clustering butterflies and birds on the incandescent flesh could be seen both as images of tenderness and, conversely, as signs of corruption and decay. Either way, this is visual poetry of the highest order.

The artist

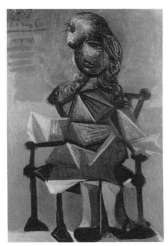

11

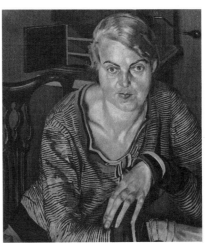

12

PABLO PICASSO 1881–1973

Born in Malaga, Andalusia; studied in Barcelona and Madrid; settled in Paris, 1904; 'Rose' period and paintings of circus folk, 1905; began series of revolutionary developments in painting with Les Demoiselles d'Avignon, *1906–7; met Braque, 1907, and created cubism; experimented with sculpture from this date and moved through a number of original styles in both media; after the monumental* Guernica, *1937, his output continued unabated but was less dramatically innovatory; probably the most versatile, influential and prolific artist of the last 150 years.*

11
Child in a chair (Maïa) 1939
(*Colour plate II, page 41*)
Oil on canvas, 55 × 38 (21¾ × 15)
Signed and dated upper left: 5.10.39./Picasso

LITERATURE C. Zervos, *Pablo Picasso, Oeuvres de 1937 à 1939,* IX, Paris 1958, no. 34.

Maïa, the daughter of Picasso and Marie-Therèse Walter, was the subject of several paintings while she and her mother lived with Picasso (Zervos, op. cit. nos. 199, 332, etc). At the outbreak of war in 1939, they left Paris to live in Royan on the Atlantic coast, where this engaging portrait of the four-year-old was painted. While still basically in the vein of those portraits of Dora Maar popularly known as 'two faced', the painting also reflects a preoccupation with figures seated in chairs (cf *Woman in a garden,* 10 December 1938).
The departure from the highly rectilinear cubism of the child's

body to the curved, sculptural features of the head suggests that Picasso may have been reminded by the child's fair hair and Nordic features of the great bronze heads inspired by her mother, Marie-Therèse Walter, at Boisgeloup, 1932; these show a very similar form of simplification and distortion (see R. Penrose, *Picasso: Sculpture, Ceramics, Graphic Work* (exhibition catalogue), Tate Gallery, London 1967, nos. 55–7).

Mizne-Blumental Collection

STANLEY SPENCER 1891–1959

Born in Cookham, Berkshire, the village where he spent much of his life and which inspired many of his paintings; gained a scholarship to study at the Slade School, 1908–12; his experiences in the First World War in the Medical Corps and in Macedonia provided themes for subsequent paintings; exhibited for a while with the New English Art Club; Spencer's style has a strong visionary and didactic quality which is at times merely eccentric but more often inspired; his best and most ambitious work is to be seen in the 1926 Resurrection *series and in the Burghclere Memorial Chapel (1932).*

12
Patricia Preece 1933
Oil on canvas, 83.9 × 73.6 (33 × 29)

LITERATURE D. Robinson and others, *Stanley Spencer* (exhibition catalogue), Arts Council, London 1976, no. 18, repr.

Stanley Spencer met Patricia Preece (1900–71) in what is now the 'Copper Kettle' tea-shop in Cookham. She was an artist who had studied in Paris under André Lhote, and was then living with a friend in a cottage near Cookham. She became Spencer's mistress and the inspiration for many of his best 'private' works in the thirties, including some very intimate nudes. The relationship lasted until their marriage in 1937 which did not survive the honeymoon. Patricia went back to her friend and Spencer remained devoted to his first wife Hilda Carline, although they did not remarry.

 This vivid portrait has a misleading air of objective realism in that it portrays Patricia in a manner that few would suppose to be flattering. It is, however, coloured both in scale and appearance by Spencer's feeling for her, as comparison with a photograph shows. He is quoted as defining her attraction as her elegance: 'To get so near an elegant woman is wonderful.' (M. Collis, *Stanley Spencer*, London 1962, p. 125.)

Southampton Art Gallery

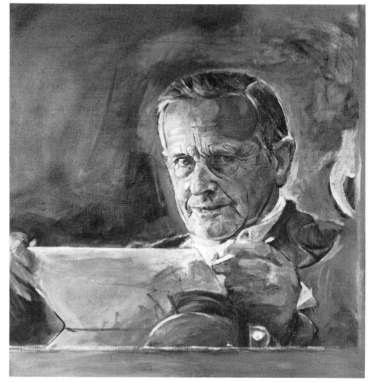

13

GRAHAM SUTHERLAND born 1903

Studied engraving at Goldsmiths' College of Art, 1921–6; taught at Chelsea School of Art, 1928–39; began to paint Welsh landscapes, c. 1931–40; served as a war artist; portraits of Somerset Maugham, 1949, followed by Sir Winston Churchill, 1954, Helena Rubinstein, 1957, Konrad Adenauer, 1963/5, and others are among his best work; designed great tapestry for Coventry Cathedral, 1952; retrospective exhibitions Venice/Paris, 1952, Amsterdam/Zürich/ Tate Gallery, London, 1953, Turin, 1965, Basle, 1966, Munich, 1967; retrospective exhibition of portraits at National Portrait Gallery, London, 1977.

13
Self-portrait 1977
Oil on canvas, 52.5 × 50.5 (20⅝ × 19⅞)
Signed and dated lower right: *G. S. 1977*

LITERATURE J. Hayes, *Portraits by Graham Sutherland* (exhibition catalogue), National Portrait Gallery, London 1977, no. 101.

The self-portrait in the twentieth century seems on the whole to have been the province of painters of expressionist tendencies, like Kokoschka, Beckmann, and, currently, Francis Bacon. Sutherland, perhaps with a certain British reticence, has waited until the age of seventy-three before producing his only major self-portrait. Unlike the brasher, more self-confident images of the painters already cited, this is a searching, introspective likeness. The artist sees himself in the act of creation – sees himself as his sitters have seen him, searching their faces for clues to what lies beyond.

Mrs Graham Sutherland

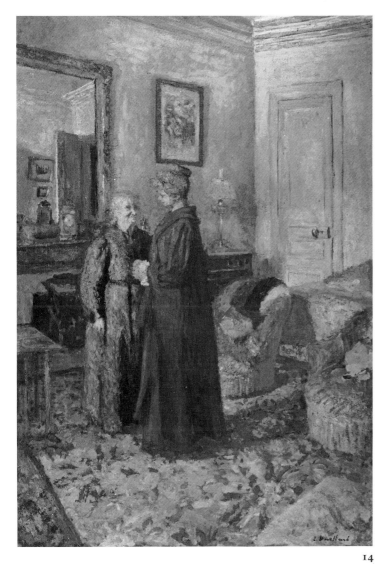

14

ÉDOUARD VUILLARD 1868–1940

French painter and lithographer, born at Cuiseaux; studied at the Lycée Condorcet in Paris with Roussel and Denis, and at the Académie Julian, 1888; there met Sérusier and Bonnard and participated in the Nabi movement from 1888; after 1914 exhibited little until his retrospective exhibition at the Musée des Arts Decoratifs, 1938; died at La Baule, escaping from the German advance.

14

Madame Vuillard et Annette 1915/16
Oil on cardboard, 75 × 51 (29½ × 20¼)
Signed lower right: *E. Vuillard*

LITERATURE J. Russell, *Vuillard*, London 1971, no. 78, repr.

Also known as *Au Salon*, this delightful glimpse of Vuillard's home life shows the painter's mother with his niece, Annette Roussel, in the appartment at 26 rue de Calais, Paris. Vuillard was devoted to his widowed mother and spent all his life with her. They lived at the rue de Calais from 1907 until two years before her death in 1928. In 1893 Vuillard's sister, Marie, had married his painter friend, Ker-Xavier Roussel. Their daughter Annette was born in 1899 and was a frequent visitor at Vuillard's flat. She appears in many of his paintings, almost every year, indeed, until she was about twenty. As the alternative title suggests, this picture was not intended as a portrait; but in the microcosm of Vuillard's art, created from the everyday material of familiar surroundings and close friends, every painting is, in the best and widest sense of the word, a portrait.

Musée Cantonal des Beaux-Arts, Lausanne

ANDY WARHOL born 1928

Born in Pittsburgh, the son of Czech immigrant parents; studied at the Carnegie Institute of Technology from 1945; settled in New York, 1949; worked as a commercial artist in the 1950s and won several awards; from 1960/1 began doing paintings with imagery intentionally derived from advertisements and comic strips; since then has made significant contributions to the development of the novel, the film and the 'happening'.

15

Six self-portraits 1966
Polymer and silkscreen on canvas, six panels, each 56 × 56 (22 × 22)

LITERATURE R. Morphet, *Warhol* (exhibition catalogue), Tate Gallery, London 1971, pp. 9–10.

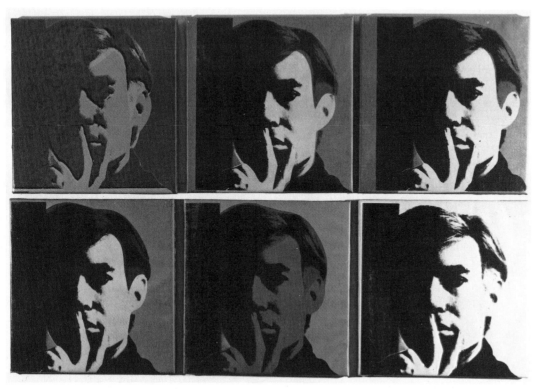

15

Warhol's multiple series, especially those of Marilyn Monroe,
Elvis Presley and Jackie Kennedy, have done much to establish
the power of a repeated image, not only as propaganda but as a
valid artistic concept. They are a device derived ultimately from
Warhol's experience in advertising, but it is a mistake to place
too much importance on the actual image. That the presentation
and the colour are of at least equal importance is clear from the
self-portraits, all produced in 1966, where the colour and surface
paint vary a great deal. Thus although it may safely be assumed
that the image shows the artist as he wished to appear, the
process of repetition is not as narcissistic as might be assumed. It
says a great deal for Warhol that his portraits convey far more
than the original photographic images from which they are
mechanically derived.

Private collection

II *Friends and models*

Portraits of the artist's friends could be sub-divided artificially into a number of categories. Like Gwen John's *Chloë Boughton-Leigh* (no. 24) or Hockney's *Celia* (no. 22), they may simply represent willing and patient models with special attractions for the artist. Schmidt-Rottluff's *Dr Schapire* (no. 32) and the various portraits of *Vollard* (nos. 17, 28, 30), on the other hand, must be seen as tributes and gestures of appreciation from the artists to friends who have supported them.

Following the demise of most varieties of narrative and historical picture, artists' models come into their own in late nineteenth- and twentieth-century painting. Now, they are seldom portrayed as other than themselves. Their identities may sometimes remain anonymous, like Matisse's *odalisques* or van Dongen's *femmes fatales* (nos. 19, 20), but they are often the subject of full-scale portraits like Kirchner's *Dodo and her brother* (no. 25).

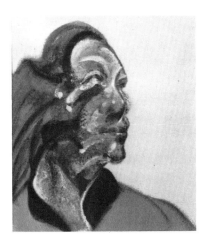 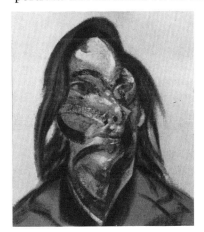 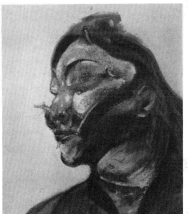

16

FRANCIS BACON born 1909

Descendant of his Elizabethan namesake, born in Dublin; came via Berlin and Paris to London, 1928, where he worked as an interior designer; virtually self-taught, he painted sporadically throughout the 1930s, destroying most of his early work; made his name with Three Studies for Figures at the Base of a Crucifixion, 1944 *(Tate Gallery) and paintings based on Velazquez's* Pope Innocent X.

16
Three Studies of Isabel Rawsthorne (on light ground) 1965
Triptych, oil on canvas, each panel 35.5 × 30.5 (14 × 12)

LITERATURE *Francis Bacon* (exhibition catalogue), Galeries nationales du Grand Palais, Paris 1972, no. 60, repr. p. 126.

Although most of Bacon's larger works are based on a highly pessimistic view of humanity, this, like many other triptych and single studies of the heads of his friends, can be seen as primarily objective in intent. The distortions of the face (with their well-documented ancestry in the art of the past, from Goya to time-lapse photography) suggest rapid and anxious movement. By repeating the image from three different angles, Bacon conveys a remarkably complete impression of the features and facial movements of an individual over a short period of time. Besides reminding us of the distortions of Picasso (cf nos. 11 and 29), the triptych form inevitably brings to mind Van Dyck's famous triple portrait of Charles I.

Mizne-Blumental Collection

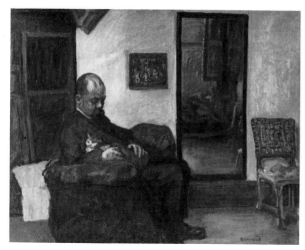

17

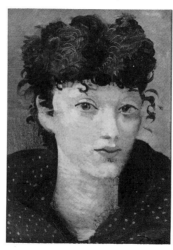

18

PIERRE BONNARD 1867–1947

French painter, born at Fontenaye-aux-Roses; gave up his law studies after selling a poster design in 1889, and associated himself with Denis, Vuillard and Sérusier in the group known as the Nabis; his early works mostly depict incidents of Parisian life in a decorative style; after an 'intimiste' phase, his later paintings become increasingly preoccupied with colour and light.

17
Ambroise Vollard 1904/5
Oil on canvas, 74 × 92.5 (29 × 36½)
Signed lower right: *Bonnard*

LITERATURE J. and H. Dauberville, *Bonnard: Catalogue Raisonné de l'Oeuvre Peint*, I, Paris 1965, p. 282, no. 306, repr.

Perhaps the most influential art dealer in history, Ambroise Vollard (1867–1939) championed many of the leading painters in Paris in the 1890s and 1900s, and sat for his portrait to three of the most important (see nos. 28 and 30). Vollard apparently upset Cézanne by falling asleep during sittings for the portrait (fig. 3) now in the Petit Palais, Paris (1899), but remembered: '. . . with him [Bonnard] I did not go to sleep, for I had a little cat on my knees to stroke' (*Recollections of a Picture Dealer*, London 1936, p. 223). Bonnard's image is typically an intimate glimpse of the home- and cat-loving Vollard, painted c.1904, when he was moving towards his mature style.

Kunsthaus Zürich

ANDRÉ DERAIN 1880–1954

French painter, born at Chatou; met Matisse while studying at the Académie Carrière, 1899; influenced by Van Gogh, and exhibited with the fauves, 1905; painted views of London for Vollard, 1906; passed through a Cézannesque phase and later turned to figure painting in a highly stylised archaic mode; a prominent member of the École de Paris, Derain was highly versatile and also produced pottery, sculpture and theatre designs.

18
Portrait of Isabel 1936
Oil on canvas, 33 × 24.2 (13 × 9¾)

LITERATURE *Derain* (exhibition catalogue), Arts Council, London 1967, no. 84, repr.

The sitter, friend and model for a number of distinguished artists, wrote that this was one of a series of five portraits which Derain painted immediately after their first meeting in the Café du Dôme, Montparnasse (letter to NPG, 13 March 1978). Herself an artist, she used to go and draw in his studio and visited him frequently before and after the war at his house in Chambourcy.

The portrait is a charming example of Derain's late decorative style and in its simplicity is perhaps reminiscent of Pompeiian wall-painting. A comparison with the *Three studies* of the same sitter by Francis Bacon (no. 16) nearly thirty years later is hardly justifiable, but it does reveal the radical difference in approach of the two artists.

Mrs Isabel Lambert

KEES VAN DONGEN 1877-1968

School of Paris painter, born in Delfshaven, Holland; worked as a draughtsman for a Rotterdam newspaper until 1897, when he settled in Paris; abandoned early heavy style and had completely mastered fauvism by the time he exhibited at the famous Salon d'Automne show of 1905; his classic fauve paintings were influential, particularly in Germany; in the 1920s and 1930s van Dongen was the most sought-after portrait painter in France, and created a number of memorably elegant images, the best of which have a more than 'period' charm.

19
La Princesse de Babylone
Oil on canvas, 81 × 65 (32 × 25½)
Signed upper right: *van Dongen*

LITERATURE *Works of art from the collection of Mr and Mrs Markus Mizne* (exhibition catalogue), The Israel Museum, Jerusalem 1966, no. 9.

This characteristic work of van Dongen's early fauve period captures perfectly the decadent atmosphere of the Parisian *demi-monde*. Its vivid colouring and exaggerated features are reminiscent of the *Femme Fatale* and *Modjesko the soprano singer* of 1908 (Museum of Modern Art, New York). The strange fall of light and greenish shadows are also a reminder that van Dongen began using electric flood-light in his studio about 1908/9 (G. Diehl, *Van Dongen*, Munich 1969, p. 49). The identity of van Dongen's model has been lost, but the title presumably refers to the oriental influence of the turban with egret feather. Van Dongen illustrated Voltaire's *La Princesse de Babylone* in 1948, and probably titled this early work from his studio at a subsequent date.

Mizne-Blumental Collection

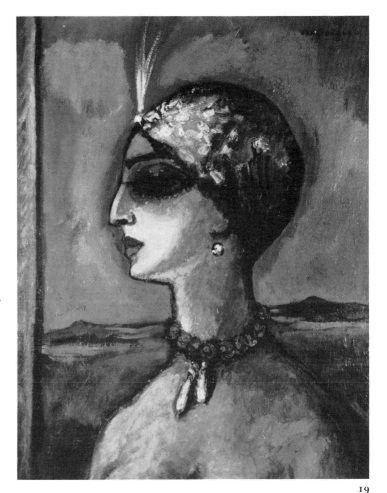

19

20
La Toilette
Colour plate III, page 44)
Oil on canvas, 110 × 80 (43¼ × 31½)
Signed lower left: *van Dongen*

This decidedly 'sexy' image shows the qualities that made van Dongen so attractive to women as a portrait painter and such an incomparable documenter of fashionable follies.

Apollinaire, in his introduction to the catalogue of van Dongen's exhibition at Paul Guillaume's in March 1918, wrote: 'Today everything that touches on a celebration of voluptuousness is overwhelmed by grandeur, and by silence. It survives among the disproportionate figures of van Dongen with their sudden and desperate colours.' These large areas of single colour

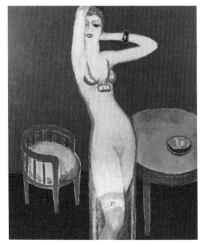

20

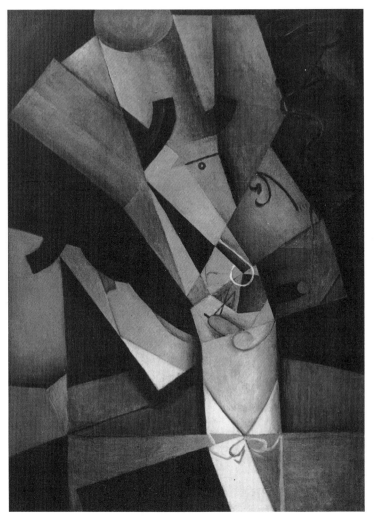

21

derive ultimately from Matisse's paintings such as *La Danse*, 1909 (Hermitage Museum, Leningrad), and the *Red Studio*, 1911 (Museum of Modern Art, New York). Van Dongen's paintings are notoriously difficult to date accurately. From the Poiret-like furniture a date of *c*.1918–20 might be hazarded, but the painting should also be compared with such works as *The Three Graces* of 1909 and *La Lecture* of 1911 (Mlle Dolly van Dongen).

Mizne-Blumental Collection

JUAN GRIS (José Victoriano Gonzales) 1887–1927

Born in Madrid, where, after his studies, he worked as a satirical illustrator; arrived in Paris, 1906, and by 1911 was painting his first serious pictures in the analytic cubist style under the influence of Picasso and Braque; he quickly developed an original and decorative form of cubism which established him as its third great representative; during the final years of sickness he devoted more time to his important writings on cubism.

21
The Smoker (Frank Haviland) 1913
Oil on canvas. 73.5 × 54.5 (28¾ × 21¼)
Signed on reverse: *Juan Gris, Céret 9–13*

LITERATURE Douglas Cooper, *Juan Gris: Catalogue Raisonné*, I, Paris 1977, no. 51.

Frank Burty Haviland, artist and dilettante, half French, half American, was born in 1885. In 1909 he bought a villa at Céret, where he kept open house for other artists, and where he became curator of the Musée in 1956 (see Audrey Davis, 'Frank Burty Haviland', *The Guardian*, 3 August 1961). Gris's highly geometric portrait of Haviland marks a prolific period of experimentation in which he was moving away from the more 'conventional' cubism of paintings like his famous 1912 portrait of Picasso (Chicago Art institute) but had not yet perfected his mature 'synthetic' style. Portraiture seems to have appealed to Gris as a medium for experimentation and by 1919/20 he was executing

pencil drawings of his friends in a completely linear style (cf *Max Jacob*, Museum of Modern Art, New York).

In this transitional work, originally known as *The Banker*, recognisable features are reorganised in flat rectilinear pieces, rather like a simple jigsaw puzzle. Unlike most of Gris's other portraits, it is doubtful whether any recognisable likeness is intended and the portrait should probably be seen as a witty comment on features associated with its model. Haviland sat to Modigliani for an intensely introverted portrait the following year (Los Angeles County Museum of Art, and Mattioli Collection, Milan).

Mr and Mrs Armand Bartos

22 23

DAVID HOCKNEY born 1937
(for biographical notes see no. 6)

22
Celia wearing checked sleeves 1973
Crayon, 65 × 50 (25¾ × 19¾)
Signed lower right: *DH Paris Dec. 1973*

LITERATURE Nikos Stangos, ed., *David Hockney by David Hockney*, London 1976, plate 344.

Celia Birtwell, fabric designer, close friend of the artist and the *Mrs Clark* of the well-known painting *Mr and Mrs Clark and Percy* in the Tate Gallery. This is one of numerous drawings in various poses executed over the past ten years, and was drawn while Hockney was living in Paris in 1973.

'Portraits aren't just made up of drawing, they are made of other insights as well. Celia is one of the few girls I know really well. I've drawn her so many times and knowing her makes it always slightly different. I don't bother about getting the likeness of her face because I know it so well. She has many faces and I think if you looked through all the drawings I've done of her, you'd see that they don't look alike.' (The artist, in *Cosmopolitan Magazine*, London, November 1974, p. 100.)

The artist

ALEXEJ VON JAWLENSKY 1864–1941

Russian painter, born in Kuslovo; during military service studied at the St Petersburg Academy; left to seek more progressive instruction in Munich, 1896; travelled extensively in France and Holland, absorbing Nabi and synthetist theories; friendly with Kandinsky and Gabriele Münter from 1908; formed the Neue Künstlervereinigung München with them, 1909, but not invited to participate in the Blauer Reiter; *in Geneva, 1914–22, then Wiesbaden until his death; formed* Die Blaue Vier *with Kandinsky, Klee and Feininger, 1924.*

23
The White Glove 1913
Oil on cardboard, 65.4 × 48.3 (25¾ × 19)
Signed upper left: *a. Jawlensky*

LITERATURE C. Weiler, *Alexej Jawlensky*, Cologne 1959, no. 150, plate 36.

Jawlensky's heads of 1913 mark a new phase in his development towards the serene abstractions of his late *meditations*. Although few of the heads are named, most of them were painted from models who regularly posed for him over a period of years. The original of this striking 'icon' has so far eluded identification, although it seems to be the same model as in several other paintings of this time, such as the *Lady with a green fan*, 1912

(Weiler, op. cit. no. 109). Weiler, probably correctly, notices a
Byzantine influence in these heads, but the closest parallel seems
to be with the fauves. One or two small heads by van Dongen in
the period 1905–10 are painted in similar exaggerated outlines
with dark, intense and frenzied colouring. With van Dongen, the
result seems decadent; with Jawlensky we are taken into the
same world of Russian mysticism manifest in the music of
Scriabin and the novels of Merezhkovsky.

Marlborough Fine Art (London) Ltd

GWEN JOHN 1876–1939

*Studied at the Slade School under Tonks with her brother Augustus; at
Whistler's school in Paris, 1898–1900; from 1900 to 1913
exhibited regularly in London to critical approval; remained in France
from c.1903, moving to Meudon, c.1914, and living in great
poverty; close friend of Rodin, Rilke and Jacques Maritain; her only
major exhibition during her lifetime was held in 1926 at the New
Chenil Galleries; died in Dieppe.*

24
Chloë Boughton-Leigh *c.1910–14*
Oil on canvas, 60 × 38 (23¾ × 14⅞)

LITERATURE *Gwen John* (exhibition catalogue), Arts Council,
London/Sheffield/Cardiff 1968, no. 16, repr.

Ellen Theodosia Boughton-Leigh (1868–1947), known as Chloë,
and her sister Maude, an artist, were both students at the Slade
and probably met Gwen John in Paris where the portrait was
painted. It is thought to have been the portrait on which she was
working in September and October 1910, and was certainly sent
to her principal patron, the American collector John Quinn, in
New York, August 1914. It represents the beginning of a change
in the artist's technique from a fluid, almost graphic style to the
use of dry chalky paint laid on in tiny brush strokes. Compared
with the earlier portrait of the same sitter in the Tate Gallery
(c.1907), the background, in particular, is different.

Leeds City Art Galleries

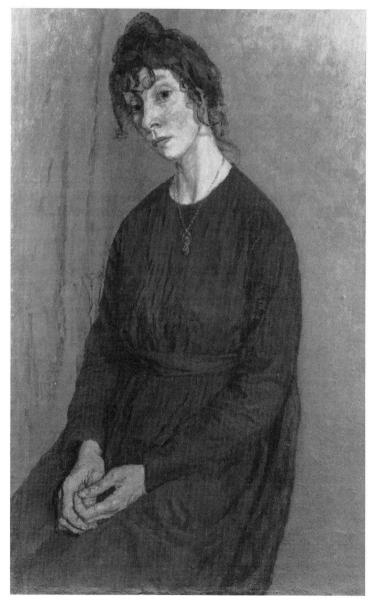

24

ERNST LUDWIG KIRCHNER 1880–1938

German expressionist painter, born in Aschaffenburg; studied architecture in Munich, but in 1905 became a full-time painter; joined Schmidt-Rottluff, Bleyl and Heckel in founding the Brücke association; settled in Berlin, 1911, where he produced most of his best work, in colours influenced by the fauves and of a psychological intensity inspired by Munch and Van Gogh; in 1915 he suffered a complete mental breakdown and moved to Switzerland after treatment; his later paintings are more decorative and less disturbing; in 1937, after the Nazis removed 639 of his paintings from German museums, he committed suicide in Davos.

25

Dodo and her brother 1908/20
Oil on canvas, 171 × 95 (67½ × 37½)
Signed lower left: *E. L. Kirchner*

LITERATURE D. E. Gordon, *Ernst Ludwig Kirchner*, Cambridge, Mass. 1968, p. 58, no. 48, plate 13.

Dodo was one of Kirchner's regular models and his closest friend during the years 1908 to 1911 when he was in Dresden. This, one of the first large-scale works to show signs of Kirchner's mature style, was formerly thought to represent the painter Erich Heckel and his wife, presumably on comparison with a rather similar single portrait of Heckel now in the museum at Hagen (Gordon, op. cit. no. 167). The gentleman is now accepted as a relative of Dodo's. Dodo was the model for many of Kirchner's nude paintings from this period, including the well-known *Nude with hat* (Frankfurt).

Gordon (op. cit. p. 58) has demonstrated how the pose, especially of the male figure, and the much foreshortened perspective derive from Munch's whole-length portraits of this period, one of which was exhibited at the Berlin Secession in 1908 (cf no. 47). The violent colours are reminiscent of the fauves (cf van Dongen, no. 19), but are distinguished by a new and expressive use of black which had so far been absent in Kirchner's palette. Despite retouching in 1920 the painting retains all the immediacy of early expressionism and is one of its first major achievements.

Smith College Museum of Art, Northampton, Mass.

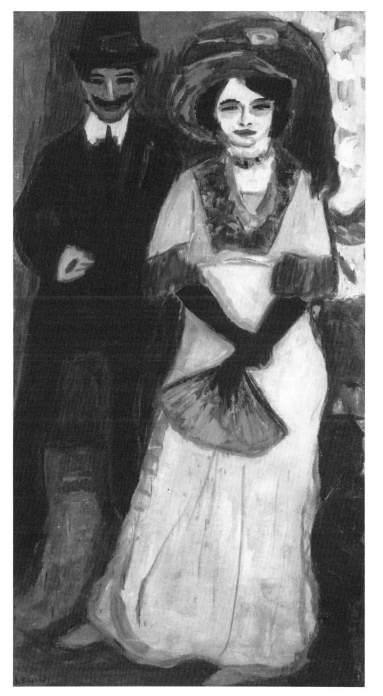

25

26

27

LUDWIG MEIDNER 1884–1966

German painter and poet, born in Bernstadt, Silesia; studied in Breslau and then, 1906–7, in Paris at the Académies Julian and Cormon, where he met Modigliani and was influenced by the fauves; in Berlin from 1908; exhibited with the expressionist avant-garde centred on Der Sturm; *founded the* Pathetiker *group, 1912; in London from 1939; settled in Darmstadt, 1953.*

26
Portrait of a lady (Resi Langer?) 1913
Lithographic chalk, 52 × 41 (20½ × 16½)
Signed and dated lower right: *L.M./1913*
Inscribed below: *Emil Frisch/zu Weihnachten 1921/ von seinem René Schickele*

LITERATURE *Drawings of Importance of the 19th and 20th Century* (exhibition catalogue), Roland, Browse & Delbanco, London 1976, no. 46 (as Mrs René Schickele), repr.

This drawing was formerly believed, on the basis of the inscription, to represent the wife of Meidner's friend, the German-Alsatian writer and poet, René Schickele. It is now clear that the inscription is a dedication only.

With Meidner, Hermann-Neisse (see no. 46) and others, Schickele was a member of the Berlin artistic circle which used to meet in the Café des Westen before the First World War. Meidner executed a number of drawings of these friends, including the cabaret artiste, Resi Langer (T. Grochowiak, *Ludwig Meidner*, Recklinghausen 1966, plate 109); her distinctive appearance, the date of the drawing and the circumstances of Schickele's ownership are strong evidence for a positive identification. It is, in any case, a superb example of Meidner's gift for expressive line and characterisation.

Roland, Browse & Delbanco

PABLO PICASSO 1881–1973
(for biographical notes see no. 11)

27
Head of a woman (Fernande) 1909
Bronze, height 42 (16½)
Inscribed: *Picasso*; numbered: 4/9

LITERATURE R. Penrose, *Picasso: Sculpture, Ceramics, Graphic Work* (exhibition catalogue), Tate Gallery, London 1967, no. 13.

Fernande Olivier, who became Picasso's mistress soon after his arrival in Paris in 1904, sat for a number of artists but has perhaps found her niche in history as the model for some of his experimental cubist works of 1909. From *c.*1908 Picasso and Braque had been working towards an analysis of form into separate geometric components in a series of paintings of landscapes and still lifes. A portrait of Fernande, painted during the summer of 1909 at Horta de Ebro (Nordrhein-Westfalen Museum, Düsseldorf), marks an important stage in the development of analytic cubism and clearly inspired Picasso to create his only large cubist sculpture. Picasso told Julio Gonzalez, in whose studio he worked, that in his early cubist paintings 'it would have sufficed to cut them up – the colours after all, being no more than indications of differences in perspective, of planes inclined one way or the other – and then assemble them according to the indications given by the colour, in order to be confronted with a "sculpture"' (Penrose, op. cit. p. 10). Although it is clear from this that the methods Picasso was applying in cubist paintings were closely related to sculpture, he attempted no more sculpture in the round for nearly twenty years, and it was left to other artists, such as Boccioni, to experiment in this field (cf *La Madre*, 1912).

Lord Rayne

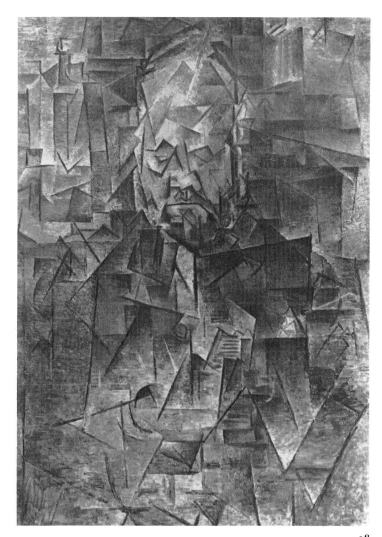

28
Ambroise Vollard 1909/10
Oil on canvas, 93 × 66 (36⅝ × 26)

LITERATURE *Chefs-d'oeuvre de la Peinture Française dans les Musées de Leningrad et de Moscou* (exhibition catalogue), Paris 1965/6, no. 60, repr.

Apollinaire was the first to notice the importance of Picasso's cubist portraits, and correctly predicted in his *Les Peintres Cubistes* (1913, p. 81) that they would be ranked among his masterpieces. The portrait of Vollard was probably begun in late 1909 but not finished until spring 1910. It shows him sitting in front of a table with, on the left, a bottle and on the right, an upended book. Picasso has even included the handkerchief in Vollard's breast-pocket. That it is undoubtedly a good likeness can be gauged from the more conventional portraits by Renoir and Bonnard (nos. 30 and 17). Vollard, who was vain, did not like it but recognised it as an important painting. It is the first of three major portraits painted in 1910, those of Wilhelm Uhde (private collection, USA) and Kahnweiler (Art Institute, Chicago) representing further stages in Picasso's exploration of the possibilities of cubism.

Pushkin Museum, Moscow

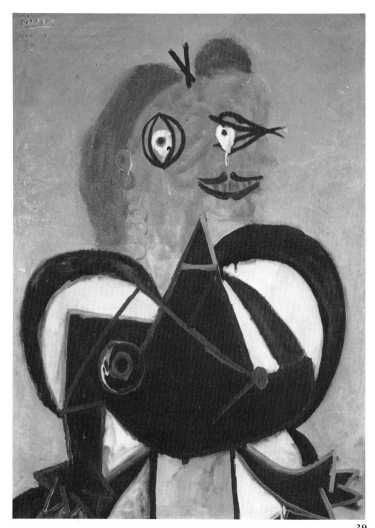

29

Lee Miller 1937
Oil on canvas, 80 × 59 (31½ × 23¼)
Signed, inscribed and dated upper left: *Picasso/Mougins/37*

LITERATURE R. Penrose, *Picasso: his life and work*, London
1958, p. 279, plate XVI/6.

Lee Miller (1907–77), well known as a war photographer and
Vogue correspondent, was painted by Picasso in the summer
of 1937 at Mougins in the south of France. Despite its
intentionally crazy abstraction, there is no doubt that the portrait
catches a good deal of her beauty and elegance. Roland Penrose

(see no. 10), later to be her husband, wrote of the portrait: 'The
profile of Lee Miller seemed all the more recognisable when
combined with large liquid eyes that had been allowed to run
with wet paint and an enormous smile from a pair of bright
green lips. It was by a combination of characteristics set out in
hieroglyphic shorthand that the person in question became
ludicrously recognisable' (loc. cit.).

Private collection, London

PIERRE-AUGUSTE RENOIR 1841–1919

*Born at Limoges, where he later worked as a ceramic decorator;
studied under Gleyre at the École des Beaux-Arts; met Monet, Sisley
and Bazille; painted with Monet along the Seine, 1869–74, and
developed the characteristic impressionist style; exhibited at four
impressionist exhibitions, 1874–82; after a visit to Italy, 1881,
evolved a more classical style; began to make sculpture in his last
years.*

30

Ambroise Vollard 1908
Oil on canvas, 81 × 64 (31¾ × 25½)
Signed and dated upper left: *Renoir '08*

LITERATURE D. Cooper, *The Courtauld Collection*, London 1954,
no. 56, plate 42.

In this, Renoir's first portrait of Vollard (cf nos. 17 and 28), the
sitter is shown as a connoisseur, examining a statuette by
Maillol. It is one of Renoir's most sympathetic late portraits, and
combines impressionist informality with a strong sense of plastic
form, which is echoed in the Maillol statuette. Vollard appears to
have been a vain man who was flattered by Renoir's image of
him, and nine years later he asked to pose for the artist as a
toreador. The result was unfortunate, and has, with some
justification, been described as the world's funniest portrait.
Renoir presented both pictures to Vollard, who sold this earlier
portrait to Samuel Courtauld in 1927.

Courtauld Institute Galleries, London

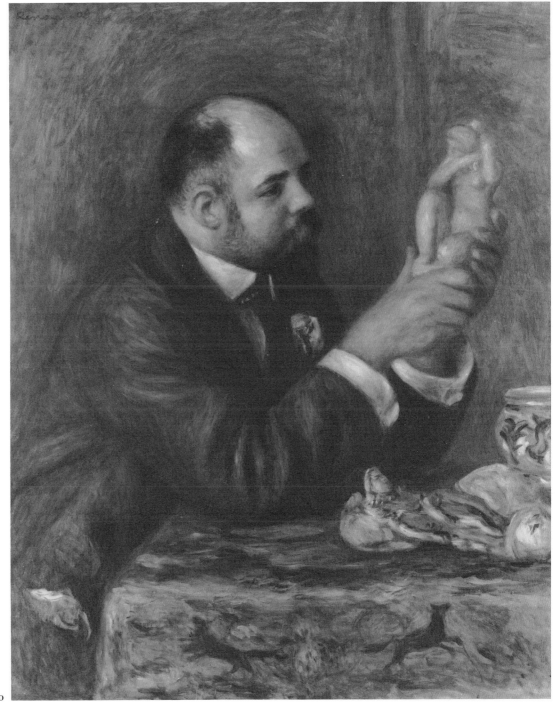

30

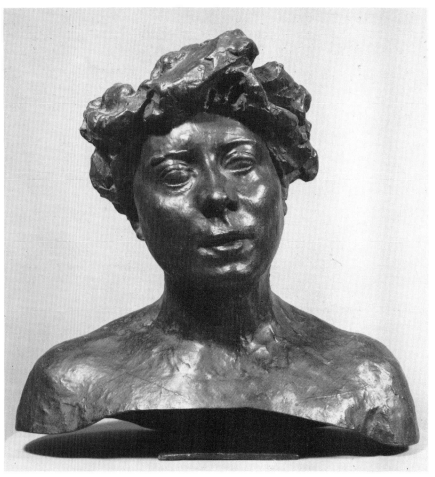

31

AUGUSTE RODIN 1840–1917

Born in Paris; worked for some years as an ornamental mason in the studio of Carrière-Belleuse; visited Italy, 1875–6, and studied Michelangelo and renaissance sculpture; exhibited The Age of Bronze, *1877, and* St John the Baptist, *1880; commissioned to make doors (*The Gates of Hell*) for the Musée des Arts Decoratifs, 1880, a project which lasted twenty years and which provided many separate figure subjects; his monument to Balzac turned down, 1898; internationally recognised after the exhibition of his works at the Paris International Exhibition, 1900; presented eighteen works to the Victoria and Albert Museum, 1914.*

31
The Duchesse de Choiseul 1908
Bronze, height 34 (13⅜)
Signed on back: *Rodin* and stamped with foundry mark

LITERATURE R. Alley, *Tate Gallery Catalogue: The Foreign Paintings, Drawings and Sculpture*, London 1959, p. 220 (6058).

Claire Coudert (died 1919) was an American who had married the Marquis (later Duc) de Choiseul in New York in 1891 and had come to live in France. She met Rodin about 1904 and appointed herself protectress until Rodin finally managed to break off the relationship in 1912.

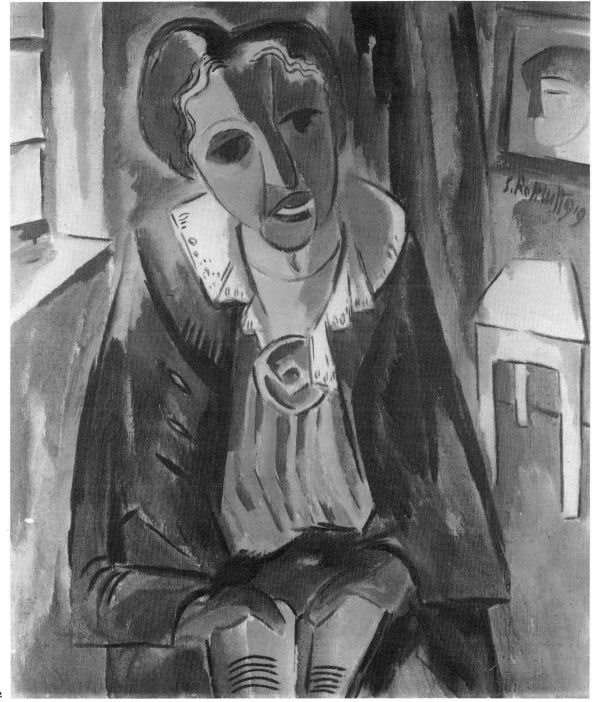

Although Rodin received many commissions for portraits after 1900 (see no. 65), he also produced less formal heads of close friends and models. This is one of three of the Duchesse; the others are a similar bronze (in the Victoria and Albert Museum) showing the sitter laughing, and a more finished marble in the Rodin Museum, Paris.

Marcel Tirel's account of Rodin's sessions with the Duchesse perhaps explains her somewhat quizzical expression: 'Some days Rodin said she looked tired; other days, he said she had done her hair badly. When the clay study was well advanced, he suddenly noticed that she wore false hair. From that day onward he modelled only her face. [She] lay down on the floor on her back, her head turned towards the light, her neck held firmly between his knees, while he modelled with his thumb, first touching her flesh and then the clay, his thumb still warm, so to speak, from her skin!' (M. Tirel, *The Last Years of Rodin*, London 1928, pp. 82–3.)

Victoria and Albert Museum

KARL SCHMIDT-ROTTLUFF 1884–1976

German expressionist painter and, with Heckel, Kirchner and Bleyl, founder member of Die Brücke; *large graphic output up to about 1927; persecuted by the Nazis and forbidden to paint, 1941; lived in Berlin from 1911.*

32
Dr Rosa Schapire 1919
Oil on canvas, 100.5 × 87.5 (39$\frac{1}{2}$ × 34$\frac{1}{2}$)
Signed and dated upper right: *S. Rottluff 1919*

LITERATURE R. Alley, *Tate Gallery Catalogue: The Foreign Paintings, Drawings and Sculpture*, London 1959, pp. 236–7.

Dr Schapire (1874–1954) was a German art historian and early supporter of the *Brücke* group. Schmidt-Rottluff became a close friend, and in 1921 designed a complete decorative scheme, including furniture, for the living-room of her Hamburg apartment. She, in turn, published a catalogue of his graphic *oeuvre* in 1924. The portrait was painted in the summer of 1919 and given to the sitter as a Christmas present by the artist and his wife. Dr Schapire bequeathed it to the Tate Gallery in 1954, with a group of other works by the artist.

Like much of Schmidt-Rottluff's work, the portrait shows the influence of African and primitive sculpture, and is a good example of the almost violent use of line and colour typical of the *Brücke*. Here the representation is tempered by friendship, although no attempt is made at flattery.

The Trustees of the Tate Gallery

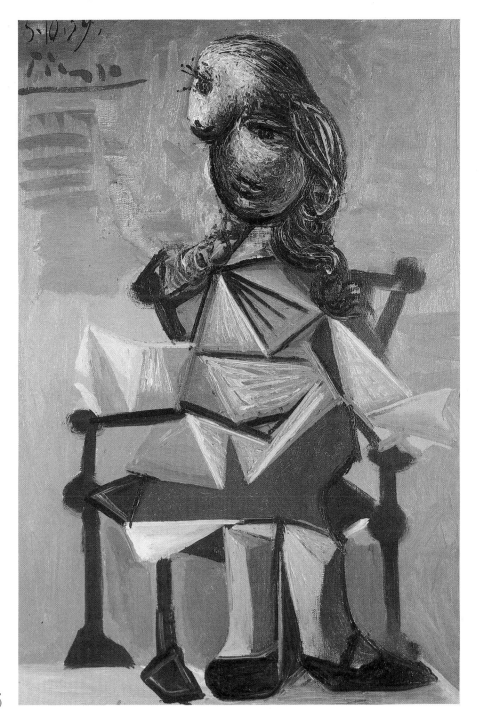

Colour plate II Pablo Picasso,
Child in a chair (Maïa) 1939 (no. 11)

33

III Intellectuals

In an age when public taste has consistently run twenty or thirty years behind current artistic trends, it is only to be expected that portraits of any well-known sitters are likely to be from the artist's own circle of friends and champions. This is true, for instance, of Munch's impressive whole-lengths of the early 1900s, like *Jappe Nilssen* (no. 47), and also of R. B. Kitaj's *James Joll and John Golding* (no. 42). Not uncommonly, an artist will take the initiative and approach his sitter out of admiration for his work, as Patrick Heron did with *T. S. Eliot* (no. 40) and Salvador Dali with *Harpo Marx* (no. 34).

Corinth's portrait of the great German writer *Gerhart Hauptmann* (no. 33) is one of the last traditional images of the literary figure in his proper surroundings. Wyndham Lewis attempted a modern solution to this iconographic approach in his portrait of *Edith Sitwell* (no. 43), but his hieratic figure is so strange and impassive that despite the piles of books everywhere it fails to rouse the appropriate associations in the spectator.

LOVIS CORINTH 1858–1925

Prussian-born painter; after studies in Königsberg and Munich, moved to Paris, 1884–7, where he was a pupil of Bouguereau and was influenced by Rubens and by modern French painting; prolific painter of portraits and religious and mythological compositions in a style which increasingly prefigures expressionism; moved to Berlin, 1900, and became leading figure in the Secession with Slevogt and Liebermann; after a stroke in 1911 turned more to highly sketchy and vivacious landscapes, especially of the Walchensee in Bavaria.

33
Gerhart Hauptmann 1900
Oil on canvas, 87 × 106 ($34\frac{1}{4}$ × $41\frac{3}{4}$)
Signed upper left: *Lovis Corinth*; inscribed and dated lower right: *Gerhart Hauptmann/October 1900*

LITERATURE *Lovis Corinth* (exhibition catalogue), Kunsthalle, Cologne 1976, no. 13, pp. 52–3, plate 9.

The greatest exponent of naturalism in German drama, Gerhart Hauptmann (1862–1946) was introduced to Corinth by their mutual friend, the Berlin painter Walter Leistikow. This canvas, one of the first of Corinth's Berlin portraits, was painted in the dramatist's flat in the suburb of Grunewald. It is known from the painter Fritz Proelss, another sitter of 1900, that Corinth worked at extraordinary speed; his portrait of Proelss was finished in two days (see C. Berend-Corinth, *Die Gemälde von Lovis Corinth*, Munich 1958, p. 192). Although firmly in a long tradition of portraits of writers, the painting nevertheless attains a new depth of psychological penetration and expressiveness, partly through the brilliant use of dramatic chiaroscuro.

Kunsthalle Mannheim

SALVADOR DALI born 1904

Spanish surrealist painter, born in Figueras; studied at the Academy of Fine Arts in Madrid, from which he was twice expelled; joined surrealists in 1929 and was influenced by Miró, Tanguy and de Chirico; developed what he described as the 'paranoiac critical method' and became the master of meticulously painted irrational juxtapositions; moved to USA, 1940–8, and later turned increasingly to religious and classical works; lives in Spain.

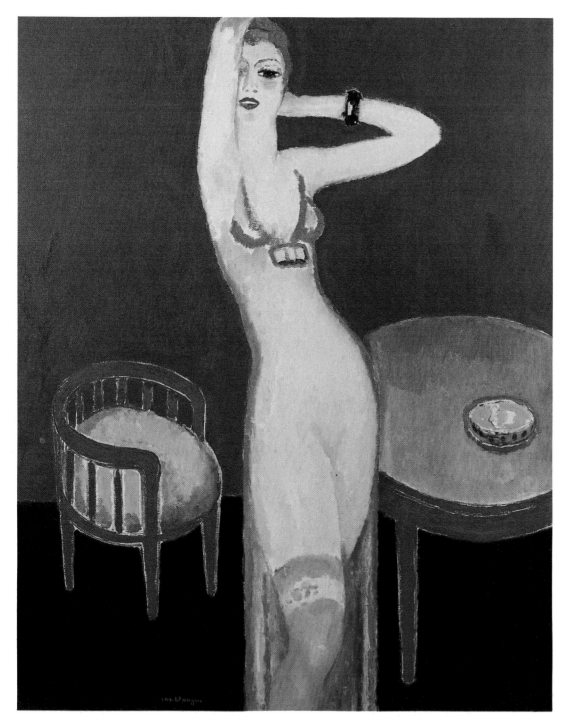

Colour plate III Kees van Dongen,
La Toilette (no. 20)

34

visit to Hollywood in 1937. It is one of two drawings of Harpo (Adolph) Marx (1893–1964), himself perhaps the most surrealist of the famous brothers. The other drawing shows him in more apprehensive mood, surrounded by burning giraffes (see J. T. Soby, *Salvador Dali*, New York 1946, p. 86). Dali's drawings of Mae West's lips for a sofa were originally projects for the décor for a Marx Brothers film which never materialised (see *Dali* [exhibition catalogue], Boymans-van Beuningen Museum, Rotterdam 1970, no. 119).

Henry P. McIlhenny Collection, Philadelphia

OTTO DIX 1891–1969

Born near Gera, Germany, where he was later apprenticed to a decorative artist; studied at Dresden School of Art, 1909–14, and then at the Düsseldorf Academy, 1919–22; earliest works characterised by intense social criticism and protest against the horrors of war; leading figure in the Neue Sachlichkeit (new objectivity) movement, 1925; Professor at Dresden Academy, 1927 to 1933, when dismissed (and later suppressed) by the Nazis; later work modelled on sixteenth-century German masters and often neo-romantic; after Second World War, transformed his style again to a late expressionism of great power.

34
Harpo Marx 1937
Pencil, 47 × 38 (18½ × 15)
Signed and dated lower right: *Gala Salvador Dali 1937*

LITERATURE *The Henry P. McIlhenny Collection* (exhibition catalogue), California Palace of the Legion of Honor, San Francisco 1962, no. 12.

Dali was no stranger to the world of the cinema and had collaborated with Luis Buñuel on the famous surrealist films *Un Chien Andalou* (1929) and *L'Age d'Or* (1931). He visited the United States on several occasions before settling there in 1940, and did much to popularise surrealism in America. This brilliant example of Dali's immaculate draughtsmanship was drawn on a

35
Adolf Uzarski 1923
Oil on canvas, 110 × 76 (43¼ × 30)
Signed and dated lower right: *Dix/1923*

LITERATURE F. Löffler, *Otto Dix: Leben und Werk*, Vienna and Munich 1967, p. 53, plate 54.

Adolf Uzarski, painter and poet, belonged, with Dix, Jankel Adler and others, to the circle of artists who exhibited at the small gallery in Düsseldorf run by the dealer, Frau Johanna Ey. As with most of Dix's work of this early period, this portrait is still very much an expressionist image, although Dix's sharp eye for characteristic detail, such as the hairs on the back of spidery hands, anticipates the merciless realism of his *Neue Sachlichkeit*

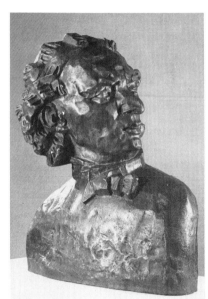

36

37

period. The satire is consciously theatrical in a double sense, for the ghastly blue light and painted neo-baroque backdrop clearly belong to the stage and probably symbolise the sham façade of bourgeois life.

Kunstmuseum Düsseldorf

FRANK DOBSON 1888–1963

British sculptor and draughtsman, born in London; apprenticed to Sir William Reynolds-Stephens, 1902–6, but first independent work mainly painting; met Wyndham Lewis after the First World War and exhibited sculpture with Group X, 1920; member, 1922, then President of the London Group, 1923–7; influenced initially by Brancusi but later by Maillol; Professor of Sculpture at the Royal College of Art, 1946–53.

36
Sir Osbert Sitwell, Bt 1923
Polished brass, $32 \times 18 \times 23$ ($12\frac{1}{2} \times 7 \times 9$)

LITERATURE M. Chamot, D. Farr and M. Butlin, *Tate Gallery Catalogue: The Modern British Paintings, Drawings and Sculpture*, I, London 1964, p. 151.

Sir Osbert Sitwell (1892–1969), essayist and poet, was, like Dobson, one of the members of the young avant-garde after the First World War. Dobson's portrait head, clearly influenced both in its degree of stylisation and choice of material (polished brass) by Brancusi, represents one of the most successful British attempts to create a portrait in the 'modern spirit'. It was

described by T. E. Lawrence, who presented it to the Tate Gallery, as: 'Appropriate, authentic and magnificent . . . as loud as the massed bands of the Guards.'

Sitwell, who sat to Dobson at his Chelsea studio in Manresa Road nearly every day for three months, relates how Lawrence would interrupt the sittings by suddenly materialising inaudibly and then, equally mysteriously, disappearing (see O. Sitwell, *Laughter in the Next Room*, London 1949, pp. 186–7).

The Trustees of the Tate Gallery

HENRI GAUDIER-BRZESKA 1891–1915
(for biographical notes see no. 4)

37
Alfred Wolmark 1913
Bronze, 65 × 55 × 40 (25½ × 21¾ × 15¾)
Signed, numbered and dated: *HGB/13/5/6*

LITERATURE R. Cole, *Henri Gaudier-Brzeska* (exhibition catalogue), Scottish National Gallery of Modern Art, Edinburgh/Leeds/Cardiff 1972, no. 20.

Gaudier-Brzeska met the Polish-born painter, Alfred Wolmark (1877–1961), in 1913, probably through the subject of Gaudier's other principal portrait bust that year, Horace Brodzky. Wolmark had himself developed an original post-impressionist style by 1910 (relatively early in British terms) and was quick to encourage the young sculptor. While Gaudier modelled this aggressively large and powerful head, Wolmark painted a portrait of Gaudier at work (Musée d'Orléans).

Gaudier had produced a number of portrait busts since his arrival in London in 1911, but most of them had been commissions which had inhibited his need to experiment. In the busts of his friends, Brodzky and Wolmark, there is a deliberate exaggeration of geometric planes in the cubist manner which is combined with a fiercely personal form of expressionism. Even today the bust of Wolmark never fails to surprise. When exhibited at the Royal Albert Hall in 1913, with five other pieces of Gaudier's sculpture, it caused an uproar.

Southampton Art Gallery

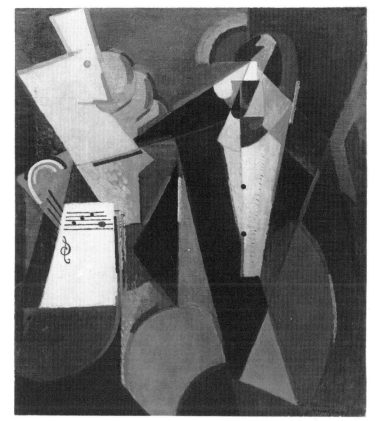

ALBERT GLEIZES 1881–1953 38

Born in Paris, Gleizes began his career in his father's textile design studio; founder member of an artists' commune, l'Abbaye de Créteil, 1906; met Delaunay, Metzinger, Picasso and the Duchamp-Villons, c.1909–10, and exhibited with the cubists at the Salon des Indépendants, 1910–11; an important writer on cubism; his painting follows that of the major cubists, especially Juan Gris, reaching its maturity in the synthetic cubist style of 1913–15; his later work is mostly in an abstract form of this style.

38
Portrait of Igor Stravinsky 1914
Oil on canvas, 130 × 114.5 (51 × 45)
Signed, inscribed and dated lower right: *Igor Stravinsky. 1914/ Albert Gleizes*

LITERATURE *Modern Portraits: The Self and Others* (exhibition catalogue), Wildenstein, New York 1976, no. 40, pp. 56–7, 183–4, repr.

Colour plate IV Ron B. Kitaj, *From London*
(James Joll and John Golding) 1975/6 (no. 42).

Gleizes had been interested in modern music since his friendship with Albert Doyen at the artists' colony of l'Abbaye de Créteil. He appears from an inscribed oil study for this picture to have met Stravinsky (1882–1971), then the *enfant terrible* of the musical world, at a performance of *Petrushka* in Paris, April 1914. The ballet had been received with enthusiasm, and Gleizes's painting is as much a tribute to the music as a portrait of its composer. Although it is quite possible to recognise features of the bemonocled young man in evening dress, the bright colours and angular rhythms of the painting are an inspired attempt to interpret the excitement of the new music in visual terms. Stravinsky himself was unimpressed and later referred to the picture as 'my moustache plus what-have-you' (I. S. and R. Craft, *Conversations with Stravinsky*, New York 1959, p. 133).

Richard S. Zeisler, New York

BERNHARD HEILIGER born 1915

German sculptor, born in Stettin; trained at the Berlin Academy under Richard Scheibe; visited Paris, 1937–8, where he was influenced by the work of Maillol, Despiau and Brancusi; Professor of Sculpture at the Berlin Academy from 1949; his early work is basically figurative and strongly influenced by Moore; since the mid 1950s has moved towards a more abstract style based on organic forms; well known in Germany for his public commissions and portrait heads.

39
Alexander Camaro 1953
Bronze, height 24 (9½)

LITERATURE H. T. Flemming, *Bernhard Heiliger*, Berlin 1962, repr. p. 178.

Most of Heiliger's portrait heads date from the 1950s onwards. They are of distinguished friends and colleagues, like the painter Karl Hofer (1951) and the composer Boris Blacher (1954), and only rarely will the sculptor undertake commissions. The head of Alexander Camaro (born 1901), a well-known painter and colleague of Heiliger's at the Berlin Academy, is an impressive example of his so-called 'abstract portraiture'. Heiliger does not

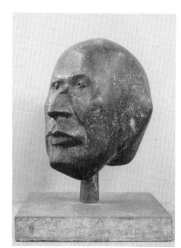

39

distinguish between a portrait and his 'free' (abstract) sculpture, and, rather like Paul Klee, sees his task as that of rendering the invisible (character) into form. Technically, this is accomplished by creating a fairly realistic study in clay which Heiliger gradually simplifies and transforms into 'pure' sculpture (see Flemming, op. cit. p. 165).

Von der Heydt-Museum, Wuppertal (Leihgabe des Bundesverbandes der Deutschen Industrie)

PATRICK HERON born 1920

Painter and writer on art, born in Leeds; studied at the Slade School, 1937–9; his early work influenced by Braque after Tate Gallery exhibition, 1946; from 1956 turned to purely abstract painting; art critic to the New Statesman, *1947–50; author of* The Changing Forms of Art, *1955,* Ivon Hitchens, *1955, and* Braque, *1956.*

40
Thomas Stearns Eliot 1949
Oil on canvas, 76.2 × 63.5 (30 × 25)
Signed and dated lower right: *P. Heron/1949*

LITERATURE *A Tribute to Herbert Read* (exhibition catalogue), Bradford Galleries and Museums 1975, no. 27.

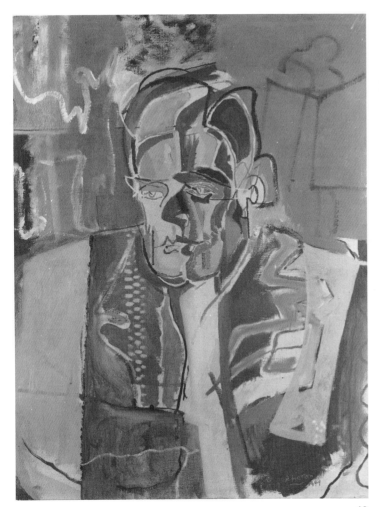

40

present portrait was worked up by late 1949. At Eliot's suggestion, Heron also painted a portrait of Sir Herbert Read, now likewise in the National Portrait Gallery. (Letter from the artist, 27 March 1966, NPG archives.)

National Portrait Gallery, London

41

Patrick Heron's portrait of the great American-born poet, T. S. Eliot (1888–1965), is one of the few instances of a cubist approach in a post-war portrait. Its highly decorative style derives from late Braque rather than a specifically formal cubism, and the image is helped to no small extent by Eliot's distinctive profile. The abstract areas may be seen as an instinctive and personal comment by the artist on his distinguished sitter.

It was Heron's admiration of Eliot which caused him to write to the poet in 1947 saying that he 'had for a long time been thinking around the problem of a portrait', and asking him if he would object to this. The outcome of sittings in 1947 and 1949 was several drawings and three oil studies, from which the

ERNST LUDWIG KIRCHNER 1880–1938
(for biographical notes see no. 25)

41
Ludwig Schames 1917/18
Woodcut, 56.5 × 26.7 ($22\frac{1}{4}$ × $10\frac{1}{2}$)
Signed left: *E. L. Kirchner*

LITERATURE G. Schiebler, *Die Graphik Ernst Ludwig Kirchners*,
Berlin 1931, no. 281.

Kirchner was introduced to the Frankfurt art dealer Ludwig
Schames by Professor Botho Gräf of Jena University in 1916.
Schames became his dealer, and through his one-man
exhibitions of Kirchner's work in late 1916 and from 1918 to
1922 did much to promote Kirchner's reputation in Germany
(see D. E. Gordon, *E. L. Kirchner*, Cambridge, Mass. 1968, p. 26).
The woodcut was probably produced while Kirchner was being
treated for an acute nervous breakdown at Dr Binswanger's
sanatorium in Kreuzlingen on Lake Constance. It is, with good
reason, one of Kirchner's most famous prints and a masterpiece
of the modern revival of the woodcut. Clearly taking advantage
of the natural shape of his piece of wood, Kirchner has produced
a slightly elongated image of hypnotic power. The piece of
sculpture on the left is probably one of Kirchner's own.

Victoria and Albert Museum

RON B. KITAJ born 1932

*American painter and graphic artist, born in Chagrin Falls, Ohio;
arrived in Britain after extensive travels, 1958; contemporary of
Hockney and Phillips at the Royal College of Art, 1959–61; since
then has lived and worked mainly in London and Spain; associated
with British groups of 'pop' artists, especially Paolozzi, 1961–3;
guest professor at Berkeley, 1967–8, and Los Angeles, 1970–1;
perhaps the most literate of the younger generation of artists, Kitaj's
work is invariably richly allusive but remains basically humanist in
approach, hence the exhibition of figure subjects,* The Human Clay,
which he selected for the Arts Council, 1976.

42

42
From London (James Joll and John Golding) 1975/6
(*Colour plate IV, page 48*)
Oil on canvas, 152 × 244 (60 × 96)

LITERATURE R. Creeley, *R. B. Kitaj, Pictures* (exhibition
catalogue), Marlborough Fine Art, London/Zürich 1977, p. 4,
no. 20, repr.

James Joll (left): born 1918; Professor of International History at
the London School of Economics; author of *The Anarchists*, 1964,
and *Gramsci*, 1977. John Golding (right): born 1929; painter and
art historian; author of *Cubism*, 1959, and *Leger and Purist Paris*,
1970. Both friends of the artist 'from London', portrayed looking
out to their various preoccupations in European thought and
culture, signified by the books and objects in the picture. The cut-
out effect of the flatly coloured figures may be one of the last
vestiges of 'pop' in Kitaj's work, but the portrait is nevertheless
an impressive monument to two intellectuals of the seventies – a
painting of great dignity and beauty.

 As Creeley has pointed out (op. cit.), Kitaj goes beyond the
detailed information surrounding his subjects and creates
surrealist puns on the paradox of the two-dimensional picture
surface. Professor Joll's head is 'repaired in the manner of certain
frescoes of Giotto'. Dr Golding's Mondrian, the ultimate in two-
dimensional paintings, is seen in perspective.

Marlborough Fine Art (London) Ltd

43

WYNDHAM LEWIS 1882–1957

Born in Nova Scotia of an American father and British mother;
studied at the Slade School, 1898–1901; exhibited in London with
the Camden Town Group, 1911, and at the second Post-Impressionist
Exhibition; influenced by futurism, he founded the vorticist group and
edited Blast; *his post-war paintings are an attempt to continue pre-*
war vorticism but are basically figurative; continued to write even
after losing his sight, 1957.

43
Edith Sitwell 1923 (completed 1935)
Oil on canvas, 86.4 × 111.8 (34 × 44)
Signed lower left: *Wyndham Lewis*

LITERATURE W. Michel, *Wyndham Lewis*, London 1971,
no. 36, pp. 98, 338, plate III.

The redoubtable poetess (1887–1964) recalled sitting to
Wyndham Lewis, at his request, every day except Sundays for
ten months in the 1920s, wearing whatever costume he might
suggest. A number of drawings in varying mood resulted from
this cooperative venture (two in the NPG), but this large oil
portrait seems to have put paid to their already strained
relationship. Edith Sitwell remembered that '. . . in the end his
manner became so threatening that I ceased to pose for him, and
his portrait of me has, consequently, no hands' (E. Sitwell, *Taken
Care Of*, London 1965, p. 100). The artist was equally unflatter-
ing about Edith and her brothers (see *Images of Edith* [exhibition
catalogue], Sheffield 1977, p. 9).

 Mrs Lewis remembered that around 1935 the artist added the
forearms (in faceted areas of bright colour) and the background,
and slightly altered the coat (Michel, op. cit. p. 338). There is no
doubt that the additions and alterations jar slightly with the
unity of Lewis's original conception, but the portrait is
nevertheless perhaps his most successful essay in this genre.

The Trustees of the Tate Gallery

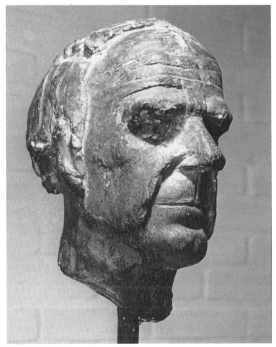

44

MARINO MARINI born 1901

Italian sculptor, painter and draughtsman, born in Pistoia; after
studying at the Florence Academy, devoted himself for many years to
painting and engraving; awarded first prize for sculpture, Rome
Quadriennale, 1935; Professor of Sculpture at the Brera Academy,
Milan, 1940–70; internationally known for his figures on horseback
and portrait heads.

44
Henry Moore 1962
Bronze, height 31.1 ($12\frac{1}{4}$)

LITERATURE R. L. Ormond, 'Acquisitions of Modern Art by
Museums – The Bust of Henry Moore by Marino Marini', in
supplement to *Burlington Magazine*, CXII, p. 340, figs. 102–6.

Unlike Marini, Henry Moore (born 1898) has produced very little
indeed that could be described as portrait sculpture. The two
men, probably the greatest figures in mid-twentieth-century
sculpture, have, however, been friends for many years and were
first introduced through the American dealer, Curt Valentin.

Despite Moore's objection to prolonged sittings, he agreed to the suggestion of a mutual friend in 1962 that Marini should do a head. It was modelled in clay, with three sittings of an hour or two's duration, and later cast in an edition of six. This cast was presented to the National Portrait Gallery jointly by artist and sitter in 1969.

Portraiture was a logical development of Marini's humanism. The sources for his style may be found in the ancient Etruscan and Roman sculpture of his homeland with perhaps some Egyptian influence, especially in his beautiful terracotta heads. To these antecedents he brings a concentrated depth of psychological realism together with his particular genius for modelling and surface texture.

National Portrait Gallery, London

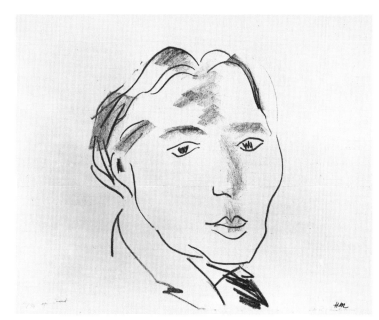

45

HENRI MATISSE 1869–1954
(for biographical notes see no. 8)

45
Alfred Cortot 1926
Transfer lithograph, 38.1 × 38.7 (15 × 15¼)
Signed on stone lower right: *H.M*; in pencil: *Henri Matisse*; numbered lower left: *2/50*

LITERATURE Susan Lambert, *Matisse Lithographs*, Victoria and Albert Museum, London 1972, no. 31, repr. p. 56.

It was perhaps appropriate that Matisse should choose the leading French pianist and conductor of his generation as the subject for one of his prints. Alfred Cortot (1877–1962) pioneered performances of modern music and wrote several volumes on the interpretation of modern French piano music.

Matisse's brilliance as a draughtsman is evident throughout his *oeuvre*. His portrait of Cortot does not aim at any psychological depth but is rather a virtuoso arabesque based on Cortot's features. Even the shading with the flat of the chalk is seen in decorative terms.

Victoria and Albert Museum

LUDWIG MEIDNER 1884–1966
(for biographical notes see no. 26)

46
Max Hermann-Neisse 1920
Tempera on card, 100 × 70 (39½ × 27½)
Signed and dated upper left: *L. Meidner/1920*

LITERATURE T. Grochowiak, *Ludwig Meidner*, Recklinghausen 1966, pp. 142–3, plate 115.

Meidner seems to have found the bizarre appearance of his fellow Silesian, the poet Hermann-Neisse, something of a challenge, for he produced at least two other portraits of him. A painting of 1913 is in the Art Institute of Chicago and a full-face drawing, also of 1920, is in Duisburg. Both paintings are masterly examples of Meidner's daringly calligraphic use of paint and colour, and demonstrate his ability to achieve a depth of psychological characterisation through an exaggeration of his sitter's features, almost to the point of caricature.

Hermann-Neisse, who had a reputation for being able to remain very still and was therefore a good model, remembered:

'I used to sit as motionless as a statue, but he, possessed by the demon of his art, stormed round me and visibly took it out on all the devils who had it in for him, a battle for existence or extinction. Afterwards, we celebrated the painter's final victory (or at least the fact that he had held his position in the battle) with a cognac, either in the studio or in a bar in the Passauer Strasse [Berlin], where the good time girls used to go . . .' (Grochowiak, op. cit. p. 143).

Leihgabe der Stadt Darmstadt im Hessischen Landesmuseum Darmstadt

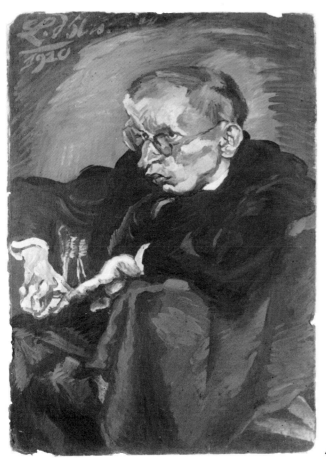

46

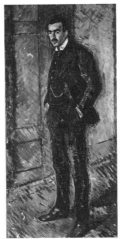

47

EDVARD MUNCH 1863–1944

Norwegian painter and graphic artist, born at Løyton; after an unhappy childhood, attended Arts and Crafts School, Oslo; in Paris 1889–92, where influenced by impressionists, Seurat and Gauguin; his works exhibited in Berlin, 1892, caused a scandal leading to the creation of the Berlin Secession and virtually also of expressionism; his symbolist-influenced woodcuts and engravings date from 1894–5; much of his work centred on a cycle of The Frieze of Life; *suffered a serious nervous breakdown, 1908–9, after which returned to Norway for good; worked on murals for Oslo University.*

47
Jappe Nilssen 1909
(*Colour plate V, page 65*)
Oil on canvas, 193 × 93 (76 × 36⅝)
Signed lower left: *E. Munch*

LITERATURE J. P. Hodin, *Edvard Munch*, London 1972, p. 128, plate 99.

Jappe Nilssen, influential Norwegian art critic, had been a friend and promoter of Munch's art for some years before the date of this portrait. After Munch's nervous breakdown in 1908, Nilssen finally persuaded him to settle in Norway, encouraged him to work again and organised another exhibition of his work. This is one of a series of whole-length portraits of friends painted around 1909. Otto Benesch (see no. 66) has pointed out how Munch shows his subjects as spare, long-limbed men, standing with unusually large feet on a tilted base so that they appear larger

than life (*Edvard Munch*, London 1960, p. 31). The forceful brushwork in semi-divisionist colours is also reminiscent of Van Gogh, an artist with whom Munch felt a close affinity at this time, partly because of his own mental breakdown.

Munch-Museet, Oslo

48
Ibsen in the Café of the Grand Hotel, Christiana 1902
Lithograph, 44 × 61 (17¼ × 24)
Signed in pencil lower right: *Edvard Munch*
LITERATURE D. Cooper, *The Courtauld Collection*, London 1954, no. 223.

Munch apparently met his distinguished compatriot, the dramatist Henrik Ibsen (1828–1906), at the controversial exhibition of Munch's paintings at Blomquist's Galleries in 1895. Ibsen interested himself in Munch's work and Munch later designed sets and costumes for Max Reinhardt's productions of *Ghosts*, 1906, and *Hedda Gabler*, 1906–7 (J. P. Hodin, *Edvard Munch*, London 1972, p. 59). This lithograph is based on a portrait in oils of 1898 (Hodin, op. cit. p. 114). A variant version also produced in 1902 shows Ibsen with spectacles, symbolically placed in front of beams from a lighthouse.

Courtauld Institute Galleries, London

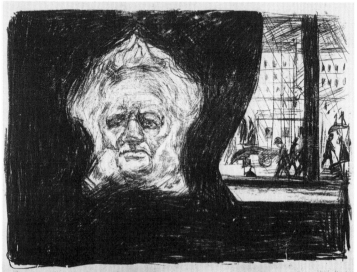

48

PAVEL TCHELITCHEW 1898–1957

Russian painter and designer, born near Moscow; fled to Kiev, 1918, where he studied with Exter, a pupil of Leger; in Berlin, 1921–3, executing theatre designs; 1923–34 in Paris where he evolved a neo-romantic style and experimented with different media; his later work became more surrealist, especially after settling in the USA, 1934, where he produced a series of large allegorical and metamorphic works; died in Rome.

49
James Joyce *c.*1928–30
Oil on canvas, 81 × 54 (32 × 21¼)
Signed lower left: *P. Tchelitchew*

LITERATURE *Pavel Tchelitchew* (exhibition catalogue), Richard Nathanson at the Alpine Club, London 1974, nos. 35 and 40.

Although the portrait is undocumented in either the Tchelitchew or Joyce literature, it seems likely that the author of *Ulysses* (1882–1941) was introduced to Tchelitchew by the artist's mentor, Edith Sitwell, at Silvia Beach's bookshop in Paris, sometime before 1930 (see Parker Tyler, *The Divine Comedy of Pavel Tchelitchew*, London 1969, p. 339).
 Tchelitchew was producing a number of portraits in the late twenties and early thirties, of which the best known are those of Edith Sitwell, Charles Henri Ford and Helena Rubinstein. His surrealist tendencies are evident only in the scale of this otherwise realistically observed likeness. Two preliminary drawings are known.

National Gallery of Ireland

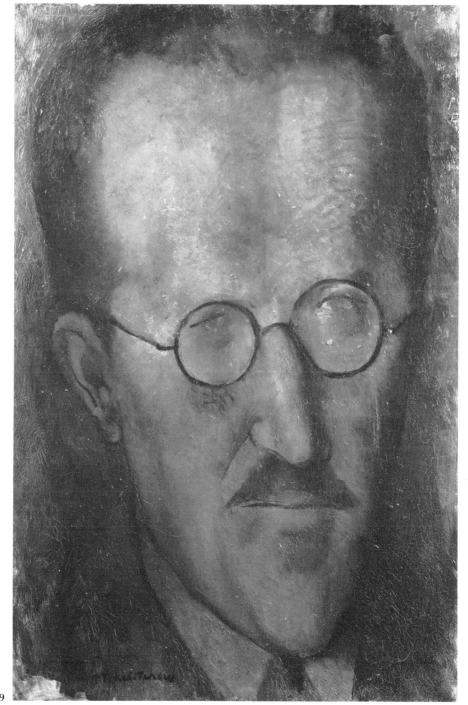

49

CHRISTOPHER WOOD 1901–30

Born near Liverpool; started painting when he left school in 1920;
spent some time at the Académie Julian, Paris, 1921; influenced by
Picasso and Cocteau; travelled around Europe until 1928, when he
returned to England; his mature style emerged that year under the
influence of Ben and Winifred Nicholson in Cumberland and Cornwall;
killed by a train on Salisbury station.

50
Constant Lambert 1926
Oil on canvas, 91.4 × 55.9 (36 × 22)

LITERATURE *Decade 1920–30* (exhibition catalogue), Arts
Council, London 1970, no. 97, repr.

Christopher Wood met the composer and conductor, Constant
Lambert (1905–51), in Paris in 1925. They became close friends
and Wood painted his first portrait of him that year (sold
Sotheby, 14 July 1971 [124]). Lambert's ballet, *Romeo and Juliet*,
was given its première by the Diaghilev Ballet with designs by
Wood the following year, and caused a riot in Paris. This scarcely
English portrait is believed to date from the same period. It was
followed in 1927 by a less sedate painting showing the composer
in bathing trunks, reclining full-length on a beach with violin
and music manuscript (Towner Art Gallery, Eastbourne). Both
portraits have a distinctly Cocteauesque feel about them, but the
principal influence in the NPG picture must be Modigliani, even
down to the pose and colour scheme. It is nevertheless one of the
most original British portraits of the inter-war years.

National Portrait Gallery, London

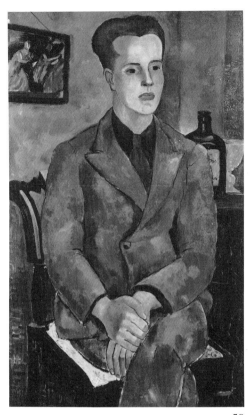

50

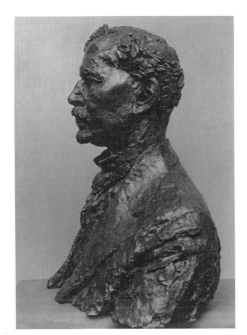

51

IV *Public figures*

There are wretchedly few official portraits of establishment figures produced during this century (or the last, for that matter) which aspire to anything more than competence. The very fact of a commission often seems enough to bring out the worst in an artist – the prospect of a confrontation with a sceptical sitter and thereafter with the combined battalions of press and media inducing an acute case of nerves. Every now and then, somebody pulls it off: Annigoni with his evocative neo-romantic vision of the Queen in 1955, and Sutherland, with the monumental dignity of his portraits of Churchill and Adenauer. The British in particular suffer not only from acute artistic squeamishness at the top but are bedevilled by a fierce chauvinism, even to the extent of exporting the talents of their least inspiring painters (Salisbury, Lavery, de Laszlo and Birley) all round the world. The Swedes' imaginative gesture in commissioning the American, Ben Shahn, to paint a portrait of Dag Hammarskjöld (no. 53) is almost inconceivable here. Significantly, it has often been left to artists like Sickert, working on their own initiative, to produce the only artistically viable images of the famous.

SIR JACOB EPSTEIN 1880–1959

Born in New York, the son of Russian Jewish emigrants; went to Paris, 1902, studying at the École des Beaux-Arts and the Académie Julian; impressed by Egyptian and ancient oriental sculpture in the Louvre; moved to London, 1905; British citizen, 1907; furore over the Strand statues, 1907, and the tomb for Oscar Wilde, 1911; met Brancusi, Modigliani and Picasso, 1912; joined Gaudier-Brzeska, Wyndham Lewis and others in founding the Vortex, 1913; came nearest to abstraction in vorticist work; reputation based on numerous portrait busts, but his monumental works remained experimental and controversial.

51
James Ramsay MacDonald 1934
Bronze, 58 × 55 × 33 (23 × 21¾ × 13)

LITERATURE R. Buckle, *Jacob Epstein, Sculptor*, London 1963, pp. 211, 235, plate 324.

Britain's first Labour Prime Minister (1866–1937) was introduced to Epstein at his own request by Sir Alec Martin, at lunch in Princes Restaurant, Piccadilly, 1926 (letter from Sir Alec Martin, 22 January 1938, NPG archives). The previous year, Ramsay MacDonald had joined in the by then predictable furore over Epstein's latest monument, the W. H. Hudson memorial *Rima* in Hyde Park, by putting his name to a letter published in *The Times*, protesting against a campaign for its removal (*Epstein, An Autobiography*, London 1955, pp. 109–10). Epstein immediately proposed sittings, which resulted in a head of which four casts were made (one in the Scottish NPG).

The present bust was likewise made at Epstein's request, shortly before MacDonald's resignation. It was considered by Sir Alec Martin and the sitter's family to be the best likeness of him. It is certainly one of Epstein's best formal portraits, partly, perhaps, because it was not a commissioned work. Even in the way the clothes and stiff collar are so expressively modelled, Epstein manages to convey a great deal of information about his subject.

National Portrait Gallery, London

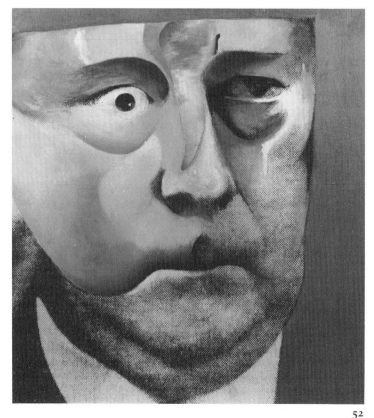

52

52
Portrait of Hugh Gaitskell as a famous monster of filmland 1964
Oil and photomontage on panel, 61 × 61 (24 × 24)

LITERATURE *Richard Hamilton* (exhibition catalogue), Tate
Gallery, London 1970, no. 68, repr. p. 49.

A detailed description of the genesis of this powerful caricature of
the distinguished Labour politician is given by the artist in the
catalogue of his exhibition at the Tate Gallery, 1970 (op. cit.). A
picture of Claude Rains made up as 'The Phantom of the Opera'
from the cover of *Famous Monsters of Filmland* (no. 10) is merged
with a newspaper photograph of Hugh Gaitskell (1906–63). The
project was occasioned by anger at Gaitskell's politics and was
started with the help of the artist's wife. It was emotionally
complicated by her death in a car accident, followed by
Gaitskell's death three months later.

Arts Council of Great Britain

BEN SHAHN 1898–1969

*American painter and graphic artist, born in Kovno, Lithuania;
emigrated to the USA, 1906; apprenticed to a lithographer,
1913–17; attended New York University, 1919, and later the
National Academy of Design; Sacco-Vanzetti Trial series, 1931–2,
set tone for much of his mature work which deals with social protest
and scenes from American life; produced murals for public buildings
and posters for government departments.*

53
Dag Hammarskjöld 1961
Pen and wash, 100 × 70 (39¾ × 27½)
Signed lower right: *Ben Shahn*

LITERATURE C. Nordenfalk, 'Ben Shahn's Portrait of Dag
Hammarskjöld', *Statens Konstsamlingars tillväxt och förvaltning
1962*, Stockholm 1962, pp. 84–7, repr. p. 89.

RICHARD HAMILTON born 1922

*Born in London; studied at the Royal Academy School and the Slade
School until 1951; taught at the University of Newcastle, 1953–66;
pupil and friend of Marcel Duchamp, whose* Large Glass *he
reconstructed; major figure in the New Realist and Pop movements in
Britain; his pictures are often montages made from the banal debris of
modern society; recent work shows increasing interest in images of
specific people.*

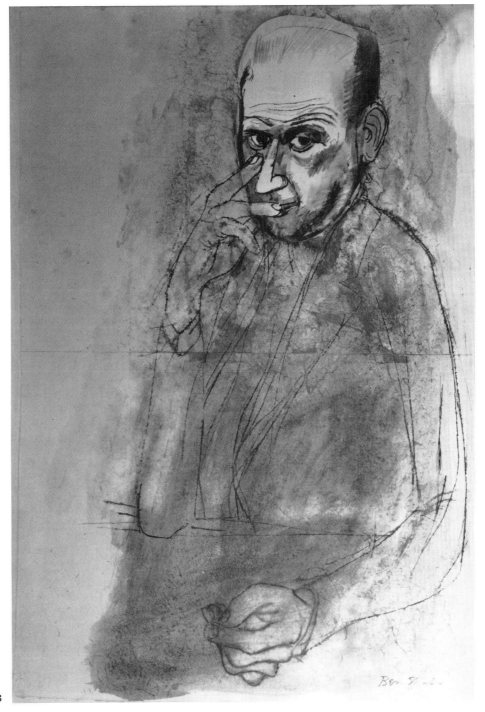

53

The painting of the then Secretary-General of the United Nations, Dag Hammarskjöld (1905–61), for which this is the preliminary drawing, was commissioned by the Swedish Government in 1959 under their 'Honorary Portraits' programme. The finished portrait in tempera now hangs in Gripsholm Castle, the Swedish National Portrait Gallery. It shows Hammarskjöld in his UN office with a view of Brooklyn Bridge through the window and a threatening atomic cloud above him. Excerpts from Hammarskjöld's famous resolution concerning the role of the UN in relation to large and small nations are lettered on the desk in front of him.

Although sittings were interrupted by Hammarskjöld's death, the drawing has perhaps several advantages over the painting in that it is unhampered by the rather self-conscious style and symbolism described above, and retains a sense of immediacy. The Swedish National Museum justified their choice of a non-Swedish, non-portrait-painter for the commission in that Shahn was a 'highly cultured artist deeply interested in human affairs', and had moreover drawn Hemingway and Freud. This amused Hammarskjöld: 'What a troika of loners', he wrote. Shahn described his approach to the portrait: 'I wanted to express his loneliness and isolation, his need, actually, for such remoteness in space that he might be able to carry through, as he did, the powerful resolution to be just.' (Nordenfalk, op. cit.)

The Dag Hammarskjöld Library at the Uppsala City Library

WALTER RICHARD SICKERT 1860–1942

British painter of Danish parentage, born in Munich; studied under Legros and Whistler from whom he learned etching; met and was influenced by Degas, 1883; exhibited with the progressive New English Art Club paintings of Dieppe, Venice and Camden Town, 1888–1914; founder member of the Camden Town/London Group, 1913; settled down in England, 1921; later work often based on Victorian illustrations and press photographs.

54
King Edward VIII 1936
Oil on canvas, 182.9 × 91.5 (72 × 36)
Signed lower right: *Sickert*

54

LITERATURE W. Baron, *Sickert*, London 1973, no. 409 (version).

Sickert's habit of painting from press photographs which took his fancy was, ironically enough, responsible for the only portrait of the Duke of Windsor to be painted during his brief reign in 1936. It is a remarkable likeness and was admired as such at the time. Indeed, considered as a painting, it is arguably the best portrait of any member of the royal family this century.

The original, in the Beaverbrook Art Gallery, Fredricton, was painted in two weeks from a press photograph by Harold J. Clemens, who was subsequently rather put out at the acclaim accorded to Sickert when the picture was exhibited at the Leicester Galleries' summer exhibition. The painting, of which this is a version, shows the King, in the uniform of an officer of the Welsh Guards, arriving at the Guards' St David's Day service on 1 March 1936.

1st Battalion, Welsh Guards

55

JOHN ULBRICHT born 1926

Born in Havana; studied at the Chicago Art Institute, and later became Assistant Director of the Denver Art Museum; came to Europe in 1954 and now lives in Mallorca with his wife, the artist Angela von Neumann; Ulbricht's early work was largely abstract but he turned to figurative painting on a greatly magnified scale, 1963/4; contributed Twelve Spanish Portraits *to the Spanish pavilion at the New York World Fair, 1965.*

55
Earl Mountbatten of Burma 1968
Oil on canvas, 162 × 114.3 (64 × 45)
Signed lower right: *ULBRICHT*

LITERATURE Robin Gibson, 'John Ulbricht's "Portrait of Earl Mountbatten of Burma", 1968', *Burlington Magazine*, CXI, p. 621, plate 56.

One of a series of large heads, executed in the late 1960s, which included such distinguished figures as John Betjeman and Robert Graves (New York State University). In working on this scale, Ulbricht attempts to come to terms with the human face (he has also treated vegetables and other organic material in this way), and creates a highly detailed study of an individual physiognomy. The results are reminiscent of a searching close-up on the cinema screen or perhaps of an area of a map under magnification.

The painting was executed in January 1968 and took about a month. There was only one sitting with Lord Mountbatten, 'perhaps it might rather be called a confrontation', the artist wrote later. The image was then worked up from sketches and photographs made at the time. 'Throughout it all I tried to preserve the immediacy of that first encounter with Lord Mountbatten and the image of him which struck me so forcibly at the time: that of a face like the great vertical superstructure of a battleship' (letter to NPG, 24 May 1969).

National Portrait Gallery, London

JAMES WYETH born 1946

The youngest of the talented Wyeth family; born in Chadds Ford, Pennsylvania, son of Andrew and grandson of N. C. Wyeth; taught by his father, he works in a similar highly detailed and precise style; his exhibited work dates from 1963, when he was seventeen, and includes portraits, landscapes and details from the Pennsylvania countryside and coastline.

56
President John F. Kennedy 1967
Oil on canvas, 40.6 × 73.7 (16 × 29)
Signed lower right: *JAMES WYETH*

LITERATURE *The Brandywine Heritage*, Brandywine River Museum, Chadds Ford, Pennsylvania 1971, no. 129, repr. p. 100.

It is a mark of James Wyeth's achievement that it always comes as a surprise to learn that this remarkable picture is in fact posthumous. The project for a portrait of President Kennedy was begun from photographs in 1966, when the artist made a number of preliminary pencil studies, including two of Kennedy's brothers, Senators Robert and Edward Kennedy (op. cit. nos. 130–6). The pose and format were worked out in stages; the addition of Kennedy's right hand in a characteristic pose seems to have been a fairly late development in the composition.

There is no doubt that such a lifelike but posthumous portrait would not have been possible a hundred years ago, without sophisticated modern techniques of film and photography. The end result is, however, decidedly more than a coloured photograph, and is a worthy act of homage by the twenty-one-year-old painter to perhaps the most charismatic political leader of our time.

James Wyeth

Colour plate V Edvard Munch,
Jappe Nilssen 1909 (no. 47)

V Patrons and the social world

58

Comparatively few important artists this century have been prepared to undertake commissioned portraits. Those who do are likely to charge a great deal as a deterrent, and to be very choosy about whom they paint. A prospective sitter seeking immortality in a portrait would almost certainly have to have some special entrée to the artist as well as a lot of money. Well aware that the great Gustav Klimt did not paint many portraits and was also very expensive, Friederike Beer (no. 62) armed herself with the promise of payment by a friend and as much of her feminine allure as she could muster, took the bull by the horns and knocked at Klimt's front door. He capitulated, but few women were so fortunate. Although artists like Hockney and Lucian Freud have recently stated that they are no longer prepared to undertake commissions for portraits of people they do not know, this by no means implies that a commissioned portrait today is doomed to failure. Many of Sutherland's best portraits are the results of commissions. It is the relationship which develops between the artist and his sitter that counts.

LOVIS CORINTH 1858–1925
(for biographical notes see no. 33)

57
Frau Luther 1911
Oil on canvas, 105 × 85.5 (41½ × 33¾)
Signed and dated upper left: *Lovis CORINTH/1911 pinxit*

LITERATURE *Lovis Corinth* (exhibition catalogue), Kunsthalle, Cologne 1976, no. 40, p. 60, plate 36.

Corinth was highly sought after as a portrait painter, but in the case of Frau Luther he took the initiative, and wrote to Herr H. Luther (letter of 5 February 1911): 'It would give me the greatest pleasure to paint a picture of Madame, your wife, for both her head and appearance are very capricious and would be enchanting to paint' (C. Berend-Corinth, *Lovis Corinth*, Munich 1958, p. 112). Sittings were held in Corinth's house in the Klopstockstrasse, and in later years he considered it to be one of his best pictures. Corinth uses the main features of the sitter's modish dress to advantage by placing the figure against a neutral background. The likeness is uncompromising and brilliantly penetrating. It is instructive to compare the portrait with the avant-garde 'chic' of Severini's *Madame M. S.* (no. 67) and the traditional elegance of Philpot's *The Hon Lady Packe* (no. 64), both painted at about the same date.

Städtische Galerie im Niedersächsischen Landesmuseum, Hanover

America that he undertook commissions. A number of these, mostly of fashionable sitters such as Helena Rubinstein, were exhibited at the Knoedler Galleries, New York, in 1943. The portrait of Mrs Isabel Styler was painted in California in 1945 after the completion of *The Apotheosis of Homer*. It is a fine example of the sort of visual pun for which Dali is famous, and with its subtitle, 'Melancolia', is a witty comment on this solemn and somewhat overdressed lady. There is a more than passing resemblance in the rocky profile on the left to Arnold Böcklin's *Isle of the Dead*, a symbolist *memento mori* by which Dali is known to have been fascinated.

Staatliche Museen Preussischer Kulturbesitz, Nationalgalerie, Berlin

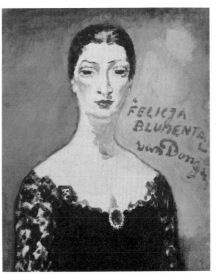

59

57

SALVADOR DALI born 1904
(for biographical notes see no. 34)

58
Mrs Isabel Styler-Tas (Melancolia) 1945
(*Colour plate VI, page 69*)
Oil on canvas, 65.5 × 86 (25¾ × 34)
Signed and dated lower right: *Salvador Dali 1945*

LITERATURE *Dali* (exhibition catalogue), Boymans-van Beuningen Museum, Rotterdam 1970, no. 76, repr.

Although Dali had previously painted several portraits, in particular of his wife, Gala, it was not until the early 1940s in

KEES VAN DONGEN 1877–1968
(for biographical notes see no. 19)

59
Felicia Blumental 1957
Oil on canvas, 65 × 54 (25½ × 21¼)
Signed and inscribed right: *a/FELICIA/BLUMENTAL/van Dongen*

Felicia Blumental, the distinguished concert pianist and recording artist, was born in Warsaw and studied at the National

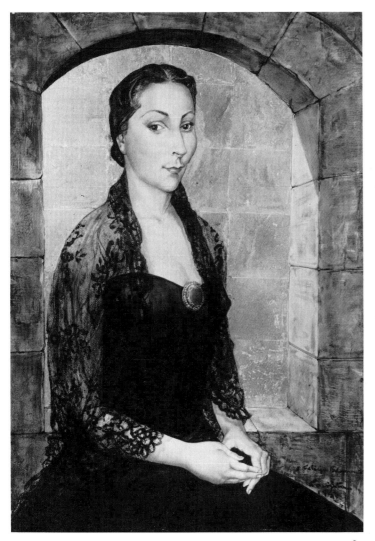

60

Conservatory under Szymanowski and Joseph Goldberg. Between 1942 and 1955 she lived in South America where she established her reputation. Since then she has played all over the world and pioneered the recording of little-known romantic works, including a Sinfonia Concertante by Szymanowski. Villa-Lobos wrote his Fifth Piano Concerto for her and Penderecki his Partita for Harpsichord and Orchestra.

 Miss Blumental and her husband were friends of van Dongen and bought several important paintings from him for their collection (see nos. 19 and 20). This elegant portrait was commissioned from the artist in Paris in 1957 when he was eighty years old and shows that he had lost little of his well-known skill in painting beautiful women.

Mizne-Blumental Collection

TSUGOUHARU FOUJITA 1886–1968

Japanese-French painter, born in Tokyo; studied at the Tokyo Academy of Art, 1906–10; visited Korea and China, 1911, and London, 1912, before settling in Paris, 1913; joined the circle round Soutine, Modigliani and Chagall; his early work is European in style, but from about 1925 he reverted to a more Japanese and calligraphic mode; he is particularly known for his paintings of cats, nudes and of himself.

60
Felicia Blumental 1957
Oil on canvas, 65 × 46 (25½ × 18⅛)
Signed, inscribed and dated lower right: *à Felicia Blumental/Foujita 1957*

During the course of a long working life in Paris, Foujita's art never became entirely westernised, and he remains impossible to classify satisfactorily under any of the fashionable '-isms'. This delicately calligraphic portrait of the pianist Felicia Blumental (see no. 59) was commissioned from him in Paris in 1957, together with a drawing. Its linear qualities and almost feline grace are typical of the Japanese feeling Foujita brings to his paintings. The evocative medieval stonework, however, is perhaps more reminiscent of the work of some of the neo-romantics of the 1940s, such as Tchelitchew, and gives an other-worldly quality to the portrait.

Mizne-Blumental Collection

Colour plate VI Salvador Dali, *Mrs Isabel Styler-Tas*
(Melancolia) 1945 (no. 58)

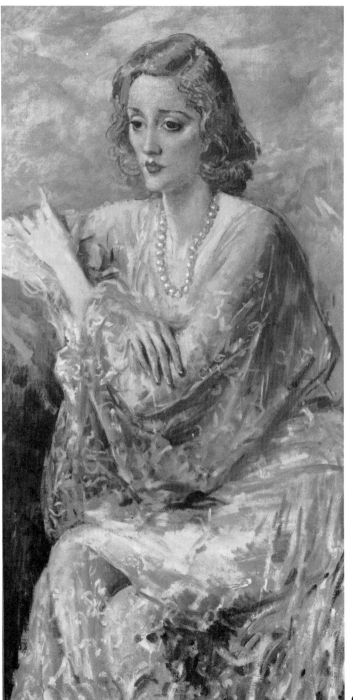

AUGUSTUS JOHN 1878–1961

Born in Tenby; studied at the Slade School, 1894–8, where he developed his talent as a draughtsman; some post-impressionist influence is evident in his landscapes and small figure studies painted in Ireland, Dorset and Wales, where he camped with gypsies and worked with Innes, 1911–14; later work more conventional, consisting largely of striking portraits, both drawings and paintings, and some decorative pictures.

61
Tallulah Bankhead 1930
Oil on canvas, 120 × 61.5 (48 × 24½)

LITERATURE Beverley Cox, 'Acquisitions of Modern Art by Museums', *Burlington Magazine*, CXII, p. 777, fig. 69.

In 1923 the American actress Tallulah Bankhead (1902–68) came to London, where she made her name in a series of popular stage plays. The climax of her career here was as Wanda Myro in Arthur Wimperis's adaptation of Louis Verneuil's *He's Mine*, which opened in October 1929. Augustus John asked her to sit for him in 1930, and agreed to her request to sell the portrait to her for £1,000 once it had been exhibited at the Royal Academy that year. It remained Tallulah's prized possession until her death, and hung in the bedroom of every house she lived in. A virtuoso mixture of characterisation and fashionable chic, it is painted in surprisingly pale, pastel colours, and shows the actress dressed in the negligée she wore for her role in the play. The portrait caused the producer Arthur Hopkins to remark that it showed the world what he had long suspected: Tallulah had a soul.

National Portrait Gallery, Smithsonian Institution, Washington DC (Gift of the Honorable and Mrs John Hay Whitney)

61

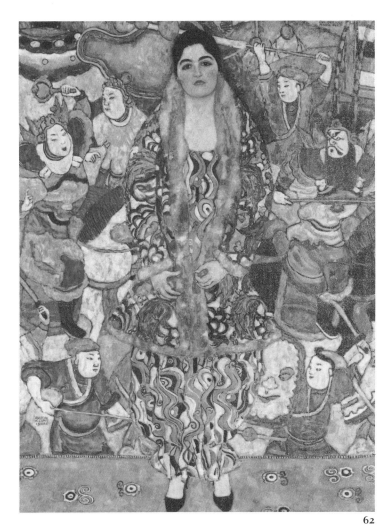

62

GUSTAV KLIMT 1862–1918

Born in Baumgarten, Austria, the eldest son of an engraver; from 1883 to 1892 worked with his brother, Ernst, and the painter Franz Matsch on large allegorical paintings; became first president of the newly formed Vienna Secession, 1897, which marked the beginning of his mature decorative and symbolist style; several of his major works, including the Vienna University ceiling, created a scandal and have not survived.

62

Friederike Maria Beer 1916
(*Cover*)
Oil on canvas, 168 × 130 (66¼ × 51¼)
Signed and dated lower left: *GUSTAV/KLIMT/1916*
Inscribed upper right: *FRIEDERIKE/MARIA BEER*

LITERATURE J. Dobai and F. Novotny, *Gustav Klimt*, Salzburg 1967, no. 196.

This masterpiece of Viennese *Jugendstil* has justly been described by Alessandra Comini as perhaps Klimt's 'greatest statement of *decoration as content*' and is documented by her to a remarkable degree in interviews with the sitter, Fr Friederike Beer-Monti, shortly before the latter's death (see A. Comini, *Egon Schiele's Portraits*, University of California 1974, pp. 129–31).

To summarise: Fr Beer was a wealthy young Viennese dilettante who collected Wiener Werkstätte products and dressed in their fabrics. In 1914 she had commissioned a full-length portrait from Egon Schiele, and now, at the age of twenty-five, she decided to ask Klimt to paint her. The portrait was paid for by her friend, Hans Böhler, a supporter of Schiele's, and cost the equivalent of $7,000. The background was not a real oriental screen but was created by Klimt from the crowded design on a Korean vase in his studio. As for her clothes and the final pose, Friederike Beer recalled: 'Klimt made me try on Chinese and Japanese robes of which he had a large collection. When I told him that I had a dress made out of hand-blocked Wiener Werkstätte silk that I called my "Klimt dress" he asked me to bring it and was enthusiastic and decided to paint me in it. Once as I started to slip my fur coat over the dress when leaving his atelier, I asked permission to put the coat on as I would like to wear it in public had I more courage; and then I put it on with its beautiful Wiener Werkstätte lining out and the fur inside. Klimt

Colour plate VII Oskar Kokoschka, *Children playing*
(The children of Dr Stein) 1909 (no. 63)

was enchanted and said it was just the thing, and so he painted me that way – standing with my fur coat turned inside out'.

Klimt's final remark on completion of the portrait was: 'Now people can no longer say that I paint only hysterical women!' (Comini, op. cit. p. 132). It is indeed the tension between the rather 'dead pan' expression on the sitter's face and the hectic patterns of the background and dress which are to a large extent responsible for the success of this remarkable work.

Mizne-Blumental Collection

OSKAR KOKOSCHKA born 1886
(for biographical notes see no. 7)

63
Children playing (The children of Dr Stein) 1909
(*Colour plate VII, page 72*)
Oil on canvas, 72 × 108 ($28\frac{1}{4}$ × $42\frac{1}{2}$)
Signed lower right: *O. K.*

LITERATURE H. M. Wingler, *Oskar Kokoschka*, Salzburg 1958, no. 19, plate II.

The Viennese bookseller, Dr Richard Stein, was an early supporter of the young Kokoschka, and had commissioned his own portrait earlier the same year (Wingler, op. cit. no. 18). Kokoschka remembered painting the two children for the way they upset his conventional notions of how to treat them. 'The Stein children came before me flushed from playing, clothes rumpled, the girl in a pink and white striped garden frock of the kind that parents seem to think appropriate for the occasion, the boy in the inevitable Sunday sailor suit . . . To keep them diverted while I was painting, I asked whether they liked to play, and whether they wanted any new toys. There was a sudden silence. I myself could no longer believe what I had said. Even their clothes now looked like a disguise. . . .' (O. Kokoschka, *My Life*, London 1974, pp. 43–4).

The portrait was one of those which caused a scandal when exhibited at the *Hagenbund* in Vienna in 1911. Although now almost impossible to see in any other way than as an intensely

memorable and moving image of childhood, its bold nervous line and aura of premonition must have seemed disturbing indeed in comparison with conventional child portraiture. As the work of a twenty-three-year-old, just out of art school, it is little short of amazing.

Wilhelm-Lehmbruck-Museum der Stadt Duisburg

GLYN PHILPOT 1884–1937

Painter and sculptor, born in London; studied at the Lambeth School of Art under Philip Connard from 1900; early work influenced by Ricketts; in Paris at the Académie Julian under J.-P Laurens, 1905; influenced by Velazquez after trips to Spain, 1906 and 1910; regular exhibitor of portraits and allegorical subjects at the Royal Academy from 1904; mural painting for St Stephen's Hall, Westminster, 1927; radical alteration in style to more modern idiom, 1932.

64
The Hon Lady Packe 1911
Oil on canvas, 198 × 114 (78 × 45)
Signed and dated lower left: *Glyn Philpot 1911*

LITERATURE K. J. Garlick, *Glyn Philpot, R.A.* (exhibition catalogue), Ashmolean Museum, Oxford 1976, no. 8.

Lady Packe, elder daughter of the 1st Baron Colebrooke, married Sir Edward Packe of Prestwold Hall in 1909. She was a lifelong friend and patron of Philpot, who painted her again in 1925, and her two daughters in 1917. This study in blacks and rose is an amazing feat of technical virtuosity by a young artist, and goes a long way towards explaining Philpot's international success as a portrait painter in the years before and after the First World War. Its ancestry is perhaps Velazquez via Whistler with a touch of Sargent; but it avoids the fashion-plate vulgarity of much Edwardian portraiture by its restraint and by the introspective characterisation, typical of Philpot at all stages of his career.

S. J. Packe-Drury-Lowe

65

AUGUSTE RODIN 1840–1917
(for biographical notes see no. 31)

65
Thomas F. Ryan 1909
Bronze, height 61 ($24\frac{1}{8}$)
Signed on front right: *A. Rodin*; inscribed with foundry mark on back

LITERATURE R. Alley, *Tate Gallery Catalogue: The Foreign Paintings, Drawings and Sculpture*, London 1959, pp. 221–2 (6060).

The Duchesse de Choiseul (see no. 31) was responsible for introducing the American millionaire, Thomas Fortune Ryan (1851–1928), to Rodin in 1909. According to a contemporary report, Ryan, like many wealthy men, was more impressed with the sculptor's conscientiousness and hard work than the finished result. Rodin took full advantage of long sittings without stopping for rest, but when Ryan left the studio he was tired from keeping still. Encouraged further by the Duchesse, Ryan presented three of Rodin's sculptures to the Metropolitan Museum, New York, and financed the purchase of seven others.

Victoria and Albert Museum

64

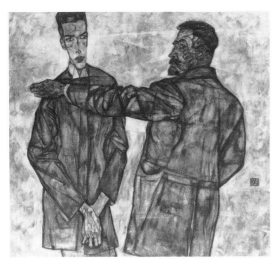

66

EGON SCHIELE 1890–1918

*Born in Tulln a.d. Donau, Austria; produced impressionistic work at
the Vienna Academy, 1906–9; joined the Wiener Werkstätte and was
influenced by Klimt; his mature, tortured and expressionistic style
developed about 1910, when his work was constantly attacked;
arrested and gaoled for making 'immoral' drawings, 1911; called up
four days after his marriage in 1913; worked as war artist; took part
in the Vienna Secession Exhibition, 1918, where his work at last
received international acclaim; died of Spanish influenza shortly
afterwards.*

66
Otto and Heinrich Benesch 1913
(*Colour plate VIII, page 77*)
Oil on canvas, 121 × 130 (47¾ × 51¼)
Signed and dated lower right: *EGON/SCHIELE/1913*

LITERATURE A. Comini, *Egon Schiele's Portraits*, University of
California 1974, pp. 117–23, plate 110.

Heinrich Benesch, a Viennese civil servant of modest means, had
known Schiele and bought pictures from him since 1910. He
regularly helped Schiele out of financial scrapes, and had visited
him three times in prison. It seems likely that he suggested a
commissioned portrait of himself, partly as a therapeutic exercise
for Schiele, and that the idea of a double portrait with his son,
Otto, was arrived at later by mutual agreement. Otto Benesch,
later to become famous as a Rembrandt expert, was seventeen,
and had already become friends with the twenty-three-year-old
Schiele.

A drawing in the Fogg Art Museum, Harvard University,
shows that Schiele's original plan was to portray the father
seated, although in much the same position. Otto already
towered over his father, and in the final painting this problem
was solved by cutting the top of his head off at the canvas edge.
Other changes took place during painting and can still be seen.
Heinrich was originally shown closer to his son and was depicted
with both hands in his pockets. Dissatisfied with the relationship
between the figures, Schiele moved him to the right and put in
his outstretched arm. The gesture is generally accepted as
signifying protection and domination of his more spiritually
inclined son. The Schiele expert, Dr Comini, even sees the
extended triangle in the faceted monochrome background, which
begins at Otto's left eye and continues beyond his father's head,
as symbolic of an 'insight into the spiritual-intellectual world'
(op. cit. p. 121). Whatever the significance of the background,
this is one of Schiele's most geometrically 'cubist' and restrained
paintings. The portrait of Otto Benesch in particular is a
masterpiece of the intense psychological probing and enormous
sense of style which characterise Schiele's work.

Neue Galerie der Stadt Linz

GINO SEVERINI 1883–1961

*Italian futurist painter; born in Cortona, Tuscany; met Boccioni in
Balla's studio, 1900; worked as a copyist until 1906 when he moved
to Paris; early work influenced by pointillists; met and was influenced
by Picasso and his circle; signed futurist manifestos on painting,
1910, and exhibited with futurists from 1912; work mainly cubist
from 1916 until the 1920s when he reverted to a neo-
classical/metaphysical style; his decorative talent involved him in
mural decoration in Switzerland and Italy.*

One of the most remarkable events in the London art world in 1913 was Severini's one-man exhibition of futurist paintings at the old Marlborough Gallery in Duke Street. This portrait, painted in Paris the previous year, was not in fact one of those exhibited, but it depicts Mrs Meyer-See, the wife of a subsequent owner of the gallery, R. Meyer-See. He had formerly been manager to Martin Henry Colnaghi and was at that time founder and then director of the Sackville Gallery. Severini painted two versions of the portrait. The other version, in a private collection in Toronto, shows a small lap-dog in the lower right-hand corner of the picture instead of the newspaper and book (Martin, loc. cit.).

The principles of futurism usually imply movement, and portraits are not therefore ideal subjects. Both Boccioni and Severini, however, produced a number of portraits around this time, although the results are basically cubist in style. Severini's subject is not such a recognisable likeness as, say, Picasso's *Vollard* (see no. 28), but it is far easier to 'read' as a picture. The movement implicit in the head perhaps suggests normal social behaviour, but the newspaper and book have hardly any relevance. The cigarette and lettering on the paper are favourite cubist devices, and the overall effect is superbly decorative.

Mizne-Blumental Collection

67
Madame M. S. 1912
Oil on canvas, 93 × 65 (36⅝ × 25¾)
Signed lower right: *G Severini*

LITERATURE M. W. Martin, *Futurist Art and Theory
1905–1915*, Oxford 1968, pp. 140–1.

CHAIM SOUTINE 1893–1943

67 *School of Paris painter of expressionist tendencies, born near Minsk, Russia; managed to get to Paris, 1913, where he studied briefly at the École des Beaux-Arts and met Chagall, Laurens and others; Modigliani introduced him to his dealer, Zborowski, who helped to support him; an American collector, Dr Barnes, bought 100 of his works in 1923, which further aided his career; turned increasingly from landscapes to still life after 1925; well known for his carcasses painted in heavy impasto.*

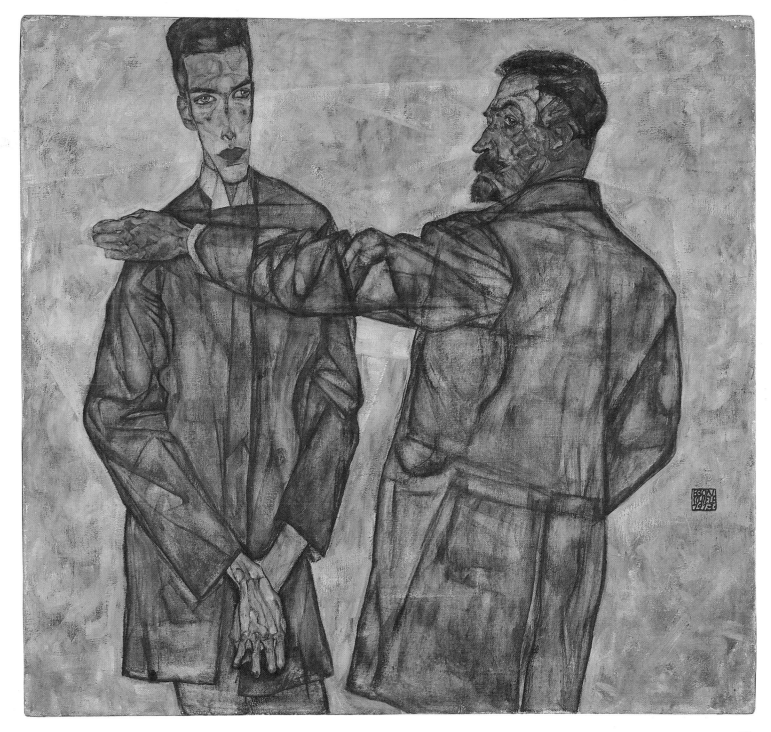

68

68
Madeleine Castaing c.1928
Oil on canvas, 100 × 73.5 (39⅜ × 28⅞)

LITERATURE D. Sylvester and M. Tuchman, *Chaim Soutine* (exhibition catalogue), Arts Council, London 1963, no. 40.

Madeleine Castaing and her husband, Marcellin, were lifelong patrons of Soutine and figured prominently in his life in the late 1920s and 1930s. From 1931 to 1935 he spent every summer at their château near Chartres. Soutine's portrait of Mme Castaing is perhaps his most imposing image of a named sitter. Having spent the early part of his life in dire poverty, he tended to prefer servants, hotel staff and the neighbours' children as models, and his fascination with uniforms is well known. While portraying his patron as elegant and worldly (she appears to be smoking), he nevertheless cannot help adding an air of unease and pathos. The regal pyramid of the composition is broken by the nervous line and brushwork, and the mood is emphasised by the threatening note of the deep blue background.

Metropolitan Museum of Art, New York (Bequest of Adelaide Milton de Groot, 1967)

GRAHAM SUTHERLAND born 1903
(for biographical notes see no. 13)

69
The Hon Mrs Reginald Fellowes 1962/4
Oil on canvas, 130 × 165 (51¼ × 65)
Signed and dated lower right: *Sutherland/62/4*

LITERATURE *Graham Sutherland* (exhibition catalogue), Haus der Kunst, Munich 1967, no. 76, repr.

The well-known society beauty, 'Daisy' Fellowes. Half French, half American, daughter of the Duc Decazes, she was the widow of Prince Jean de Broglie, when she married the Hon Reginald Fellowes in 1919. Between the wars, she was usually considered to be the world's best-dressed woman, and was constantly to be found in the pages of *Vogue*. In 1941 she became first President of the Incorporated Society of London Fashion Designers.

In 1962, shortly before she died, Mrs Fellowes sat to Sutherland in the south of France. The portrait was finished in 1964. It is one of his most ambitious yet least-known portraits, and is an inspired attempt to recreate in modern terms the traditional portrait of the society hostess and leader of fashion. David's *Mme Récamier* is an obvious predecessor.

Comtesse de Casteja, Geneva

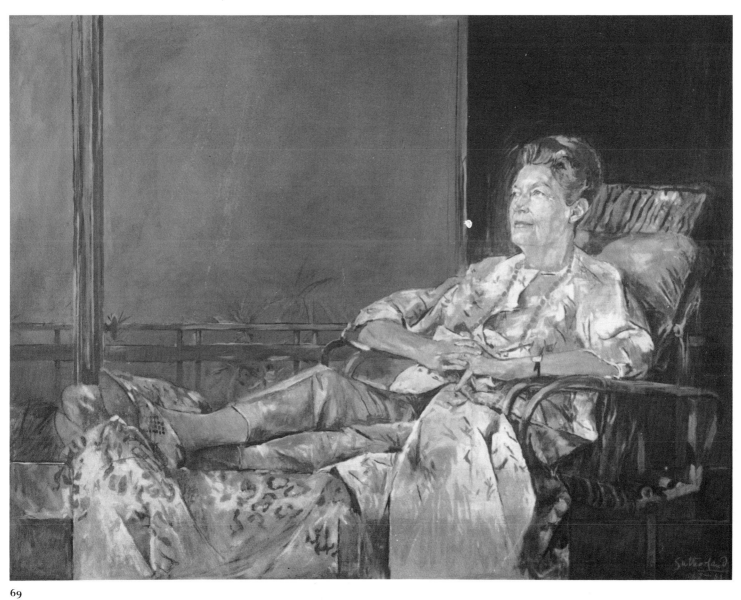

69